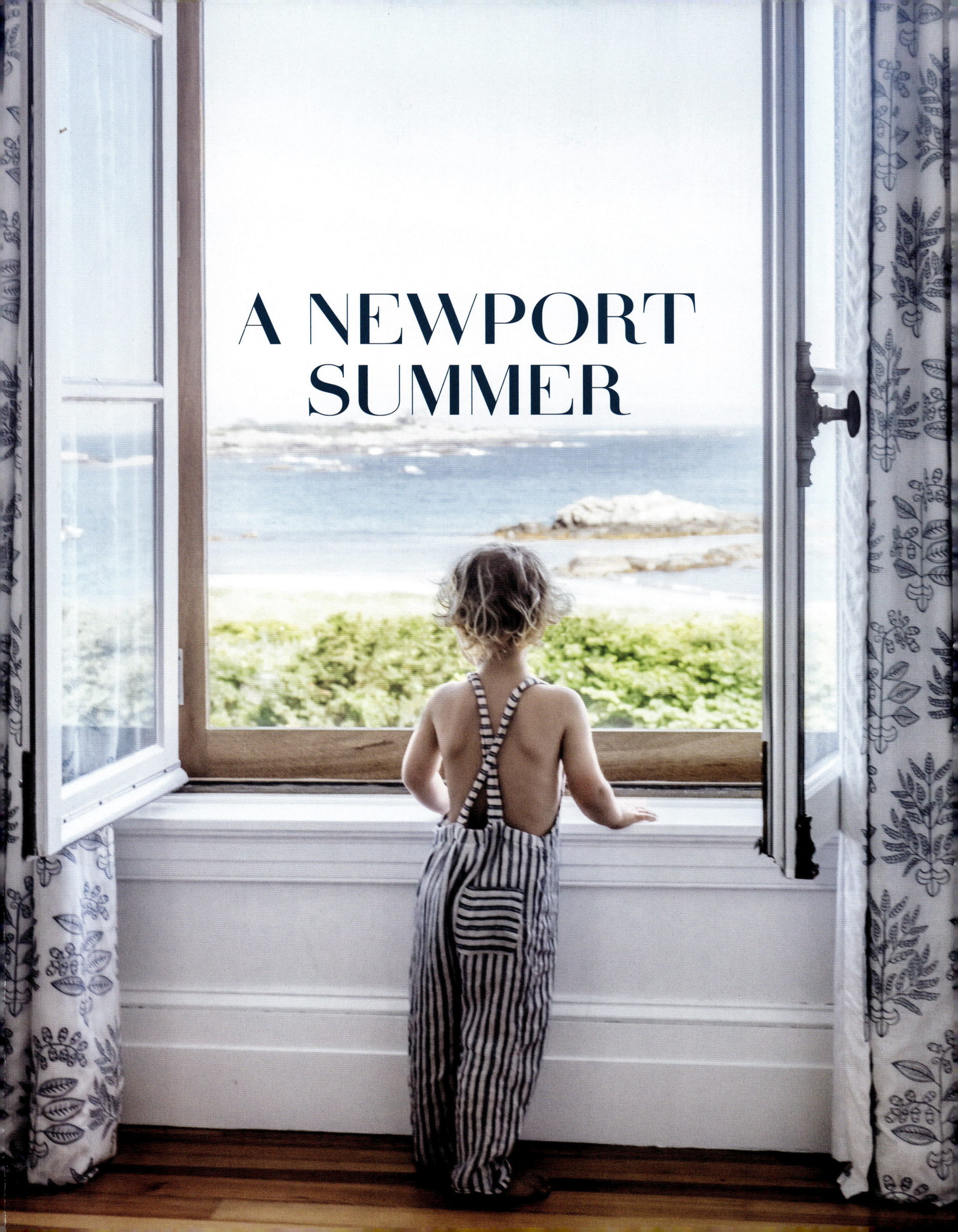

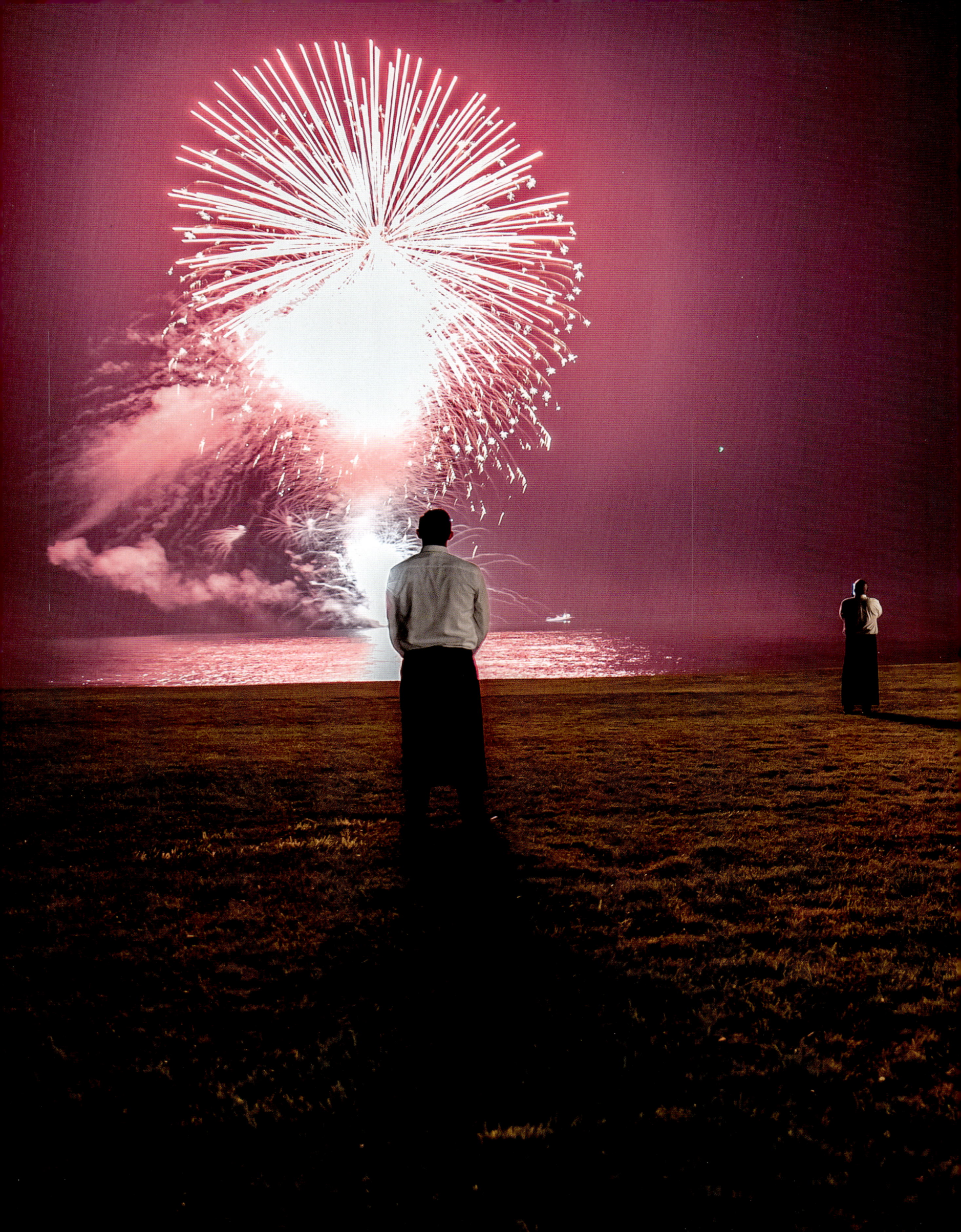

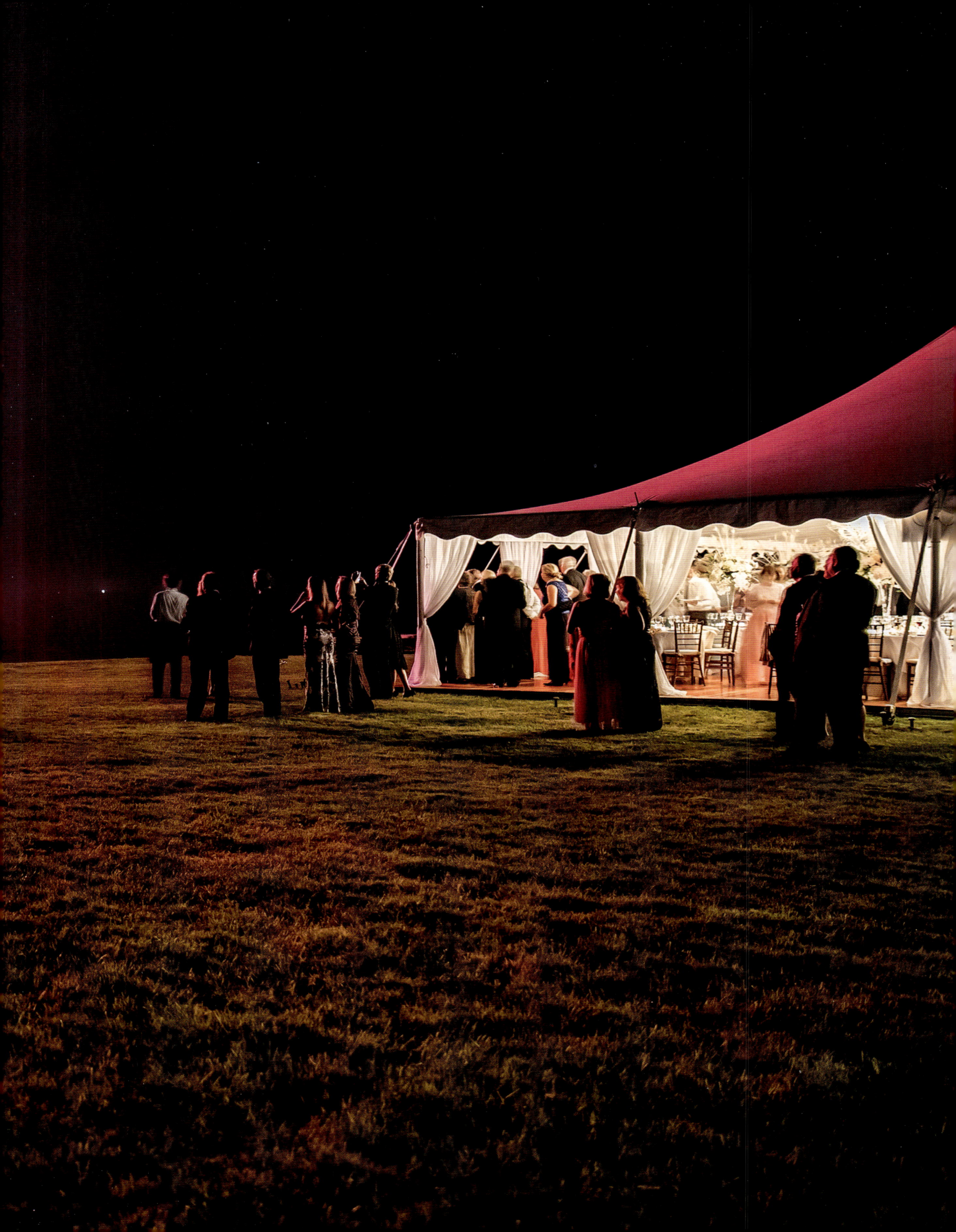

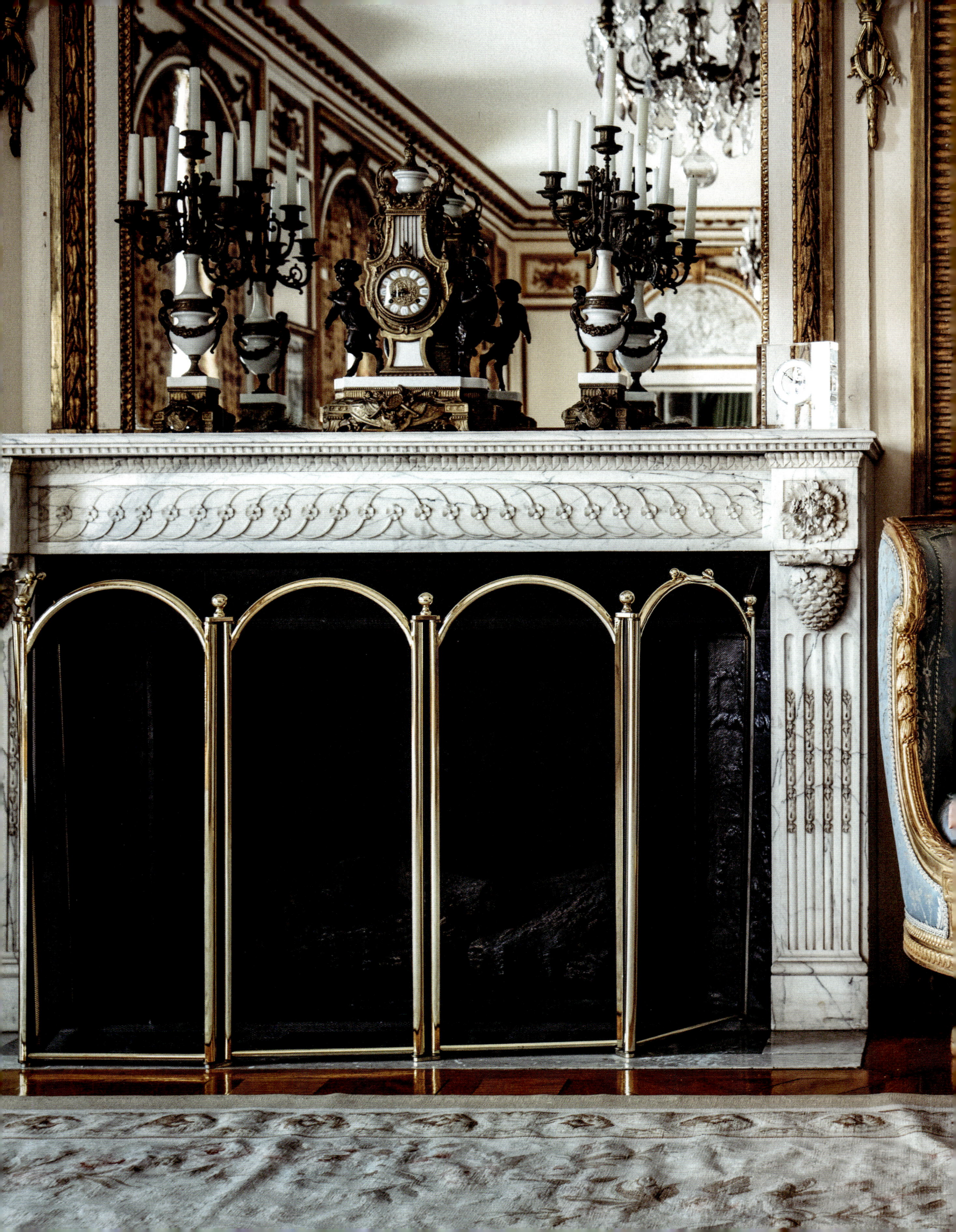

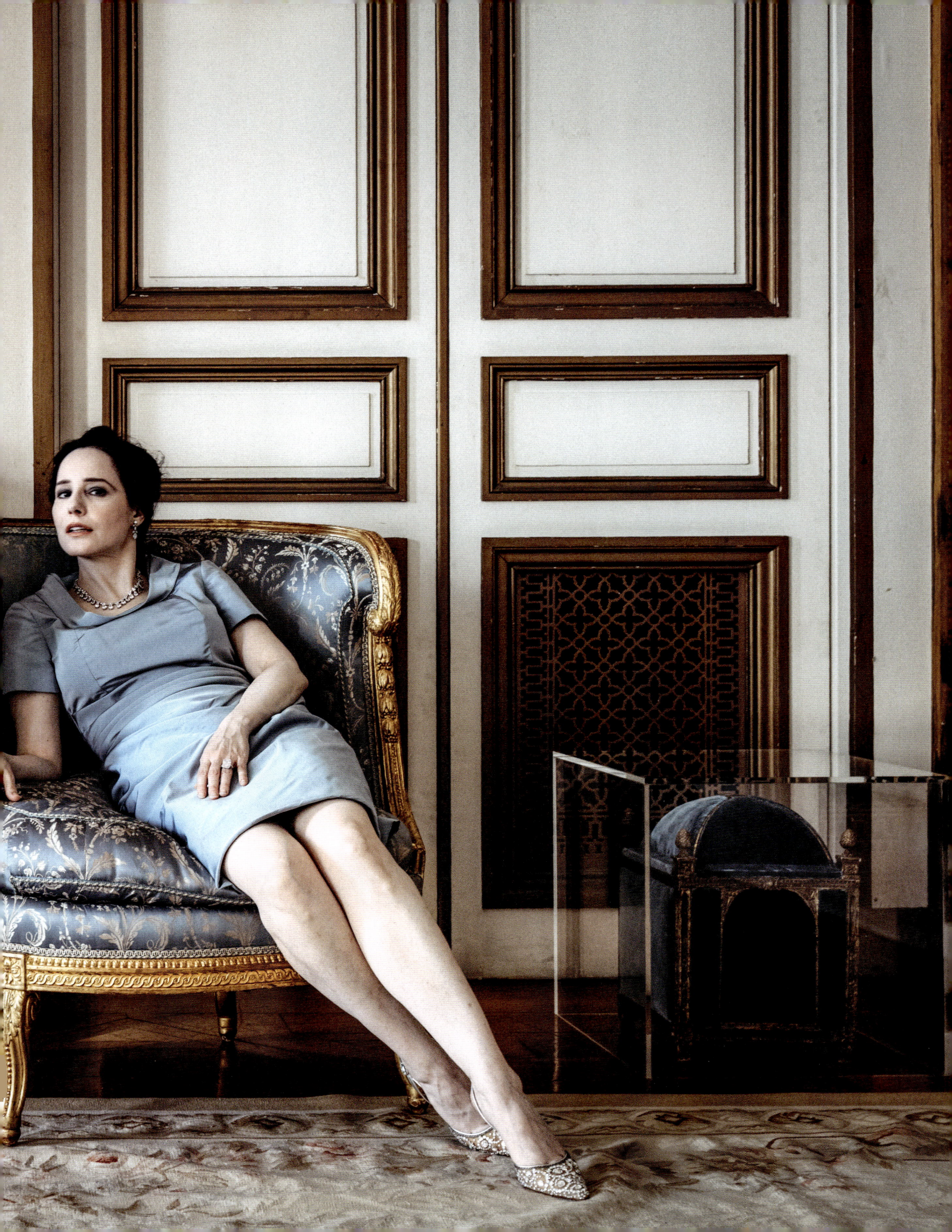

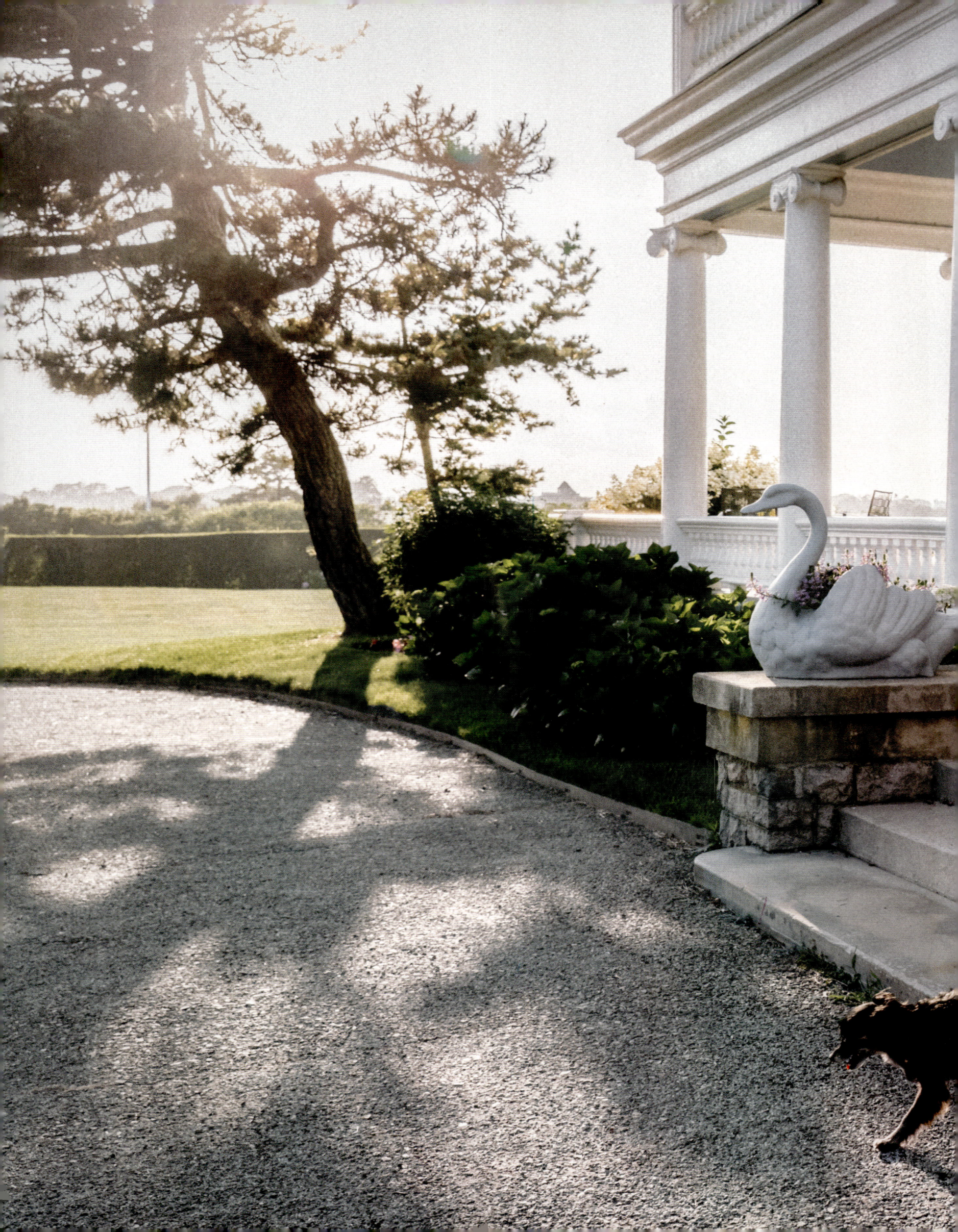

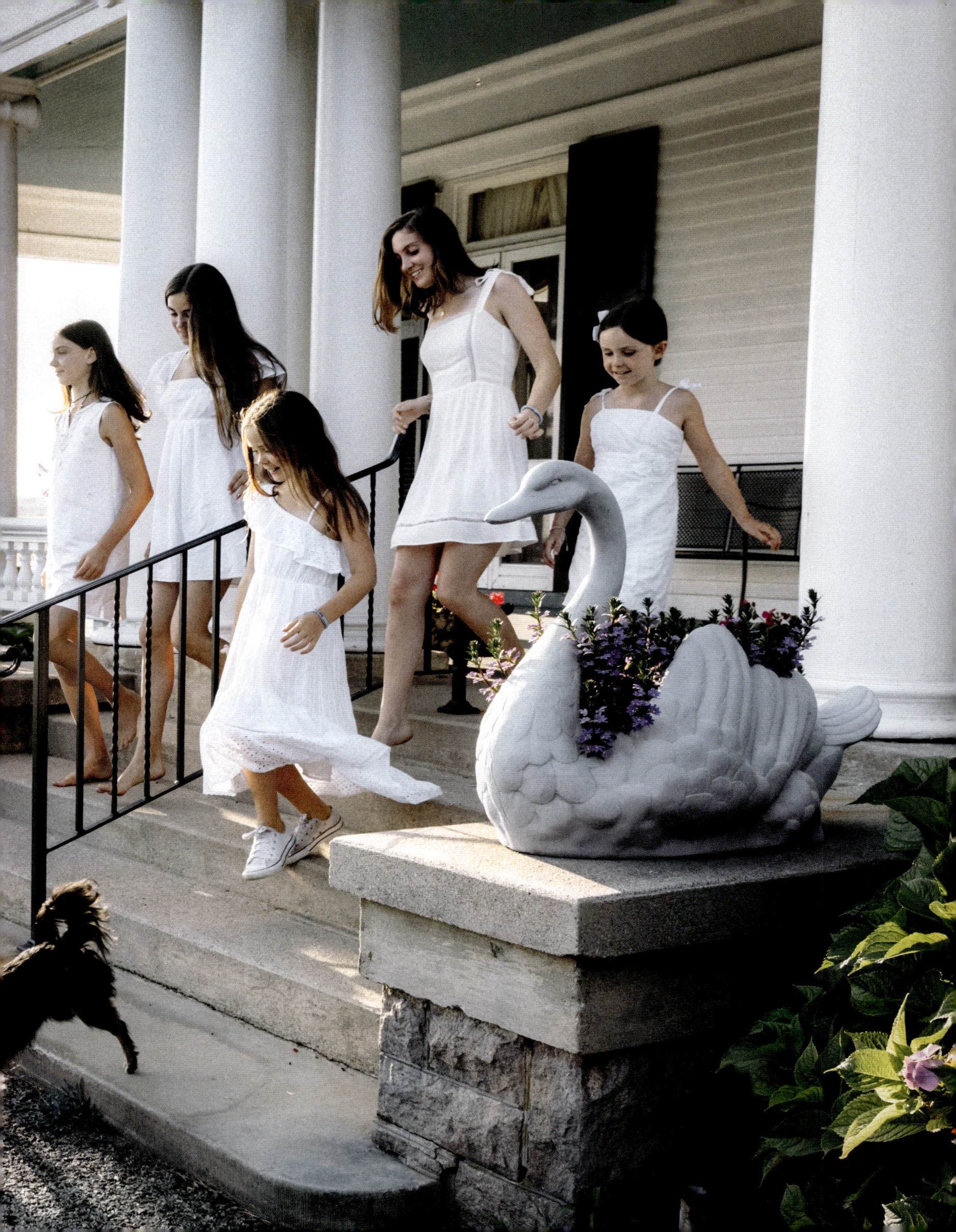

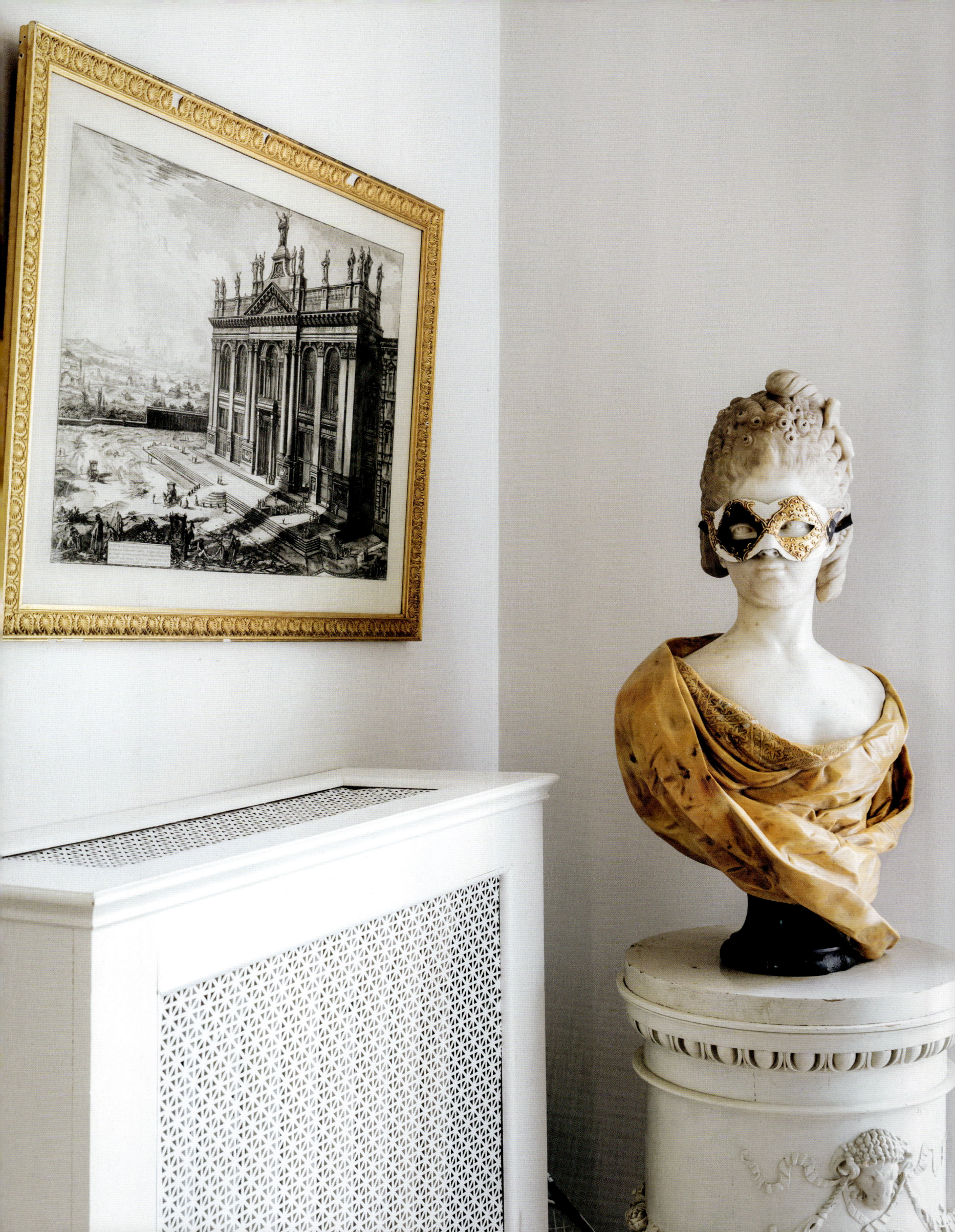

A NEWPORT SUMMER

Nick Mele & Ruthie Sommers

VENDOME
NEW YORK · LONDON

INTRODUCTION 15

JUNE 22
JULY 65
AUGUST 125
SEPTEMBER 177

ACKNOWLEDGMENTS 206

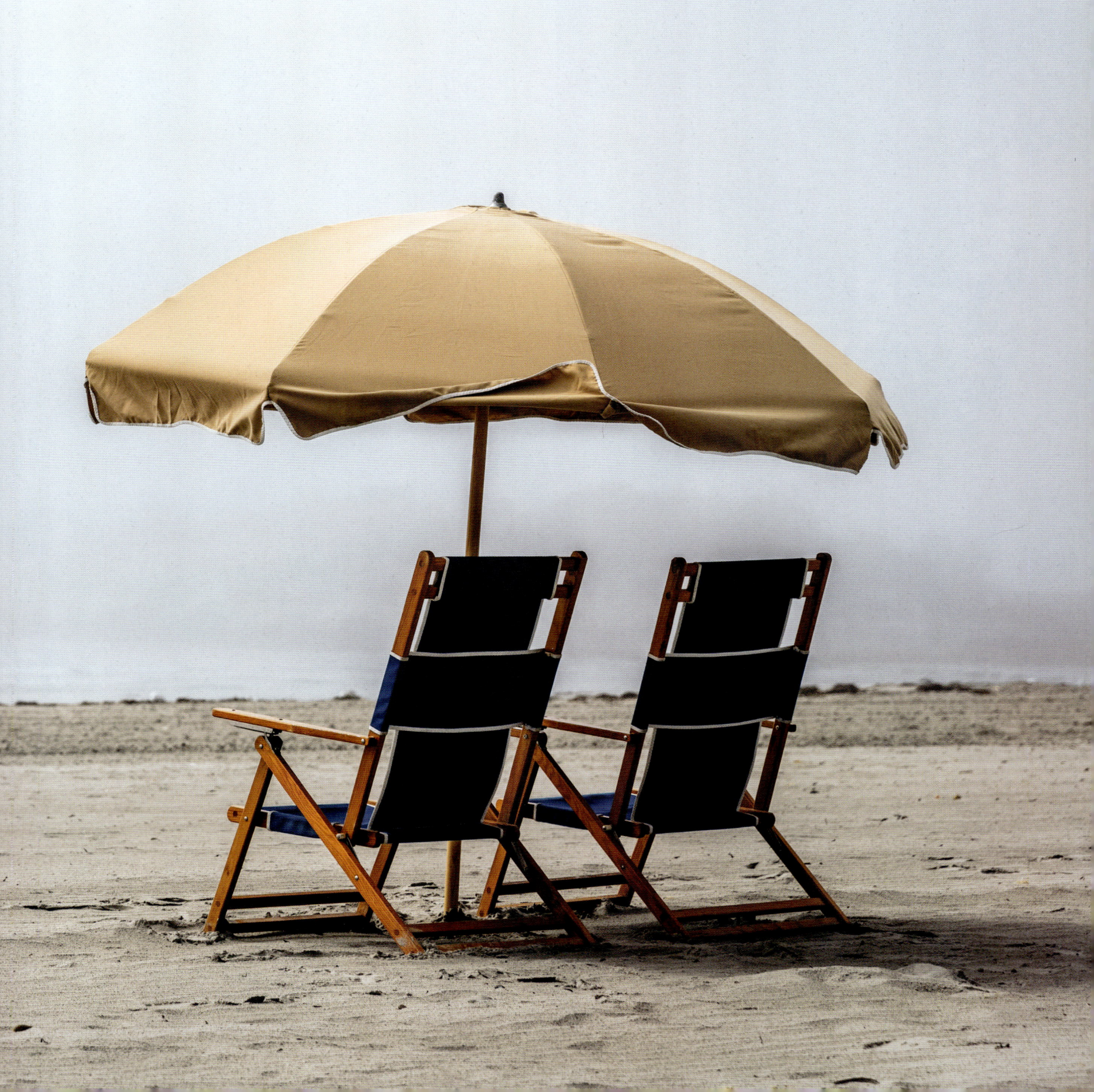

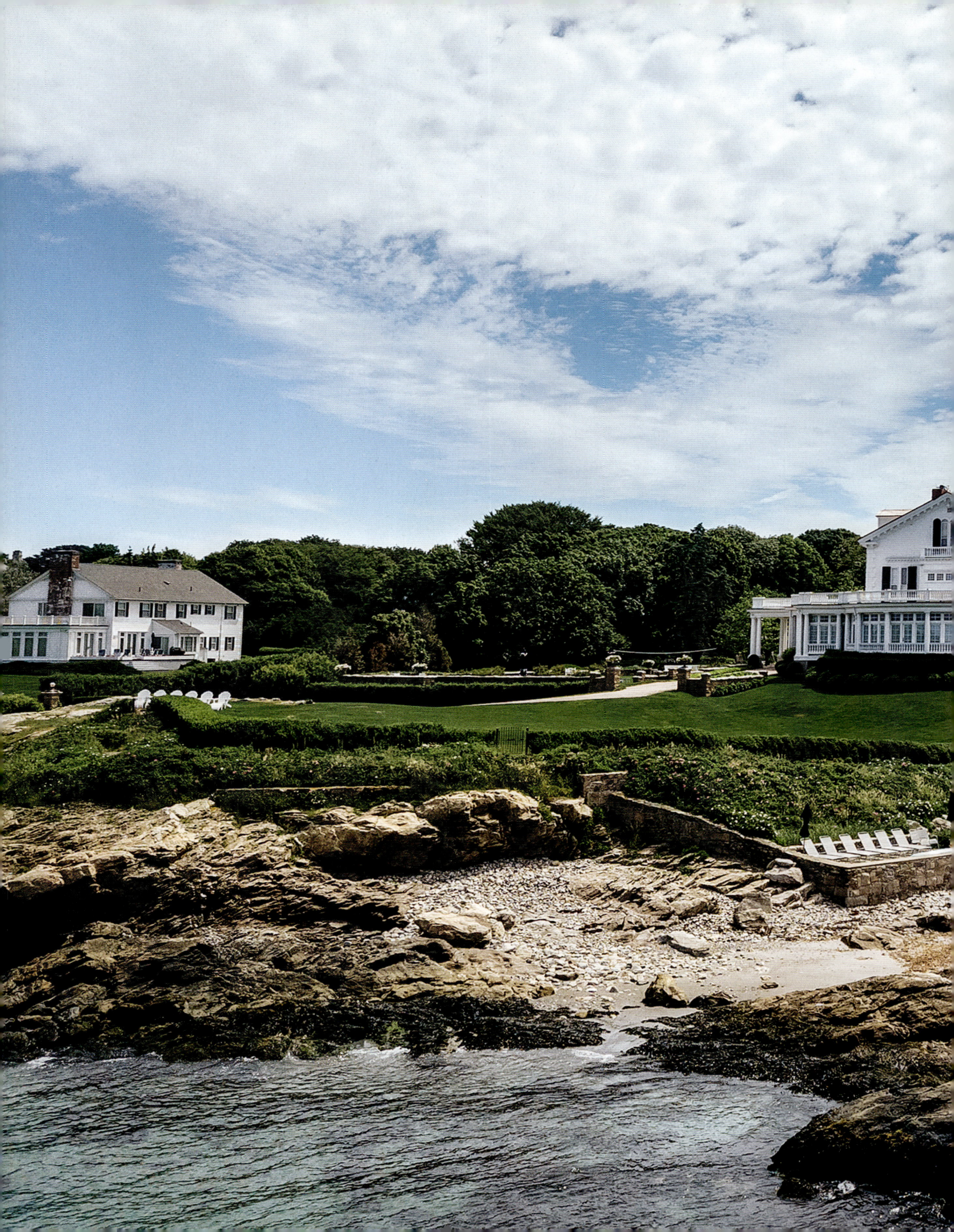

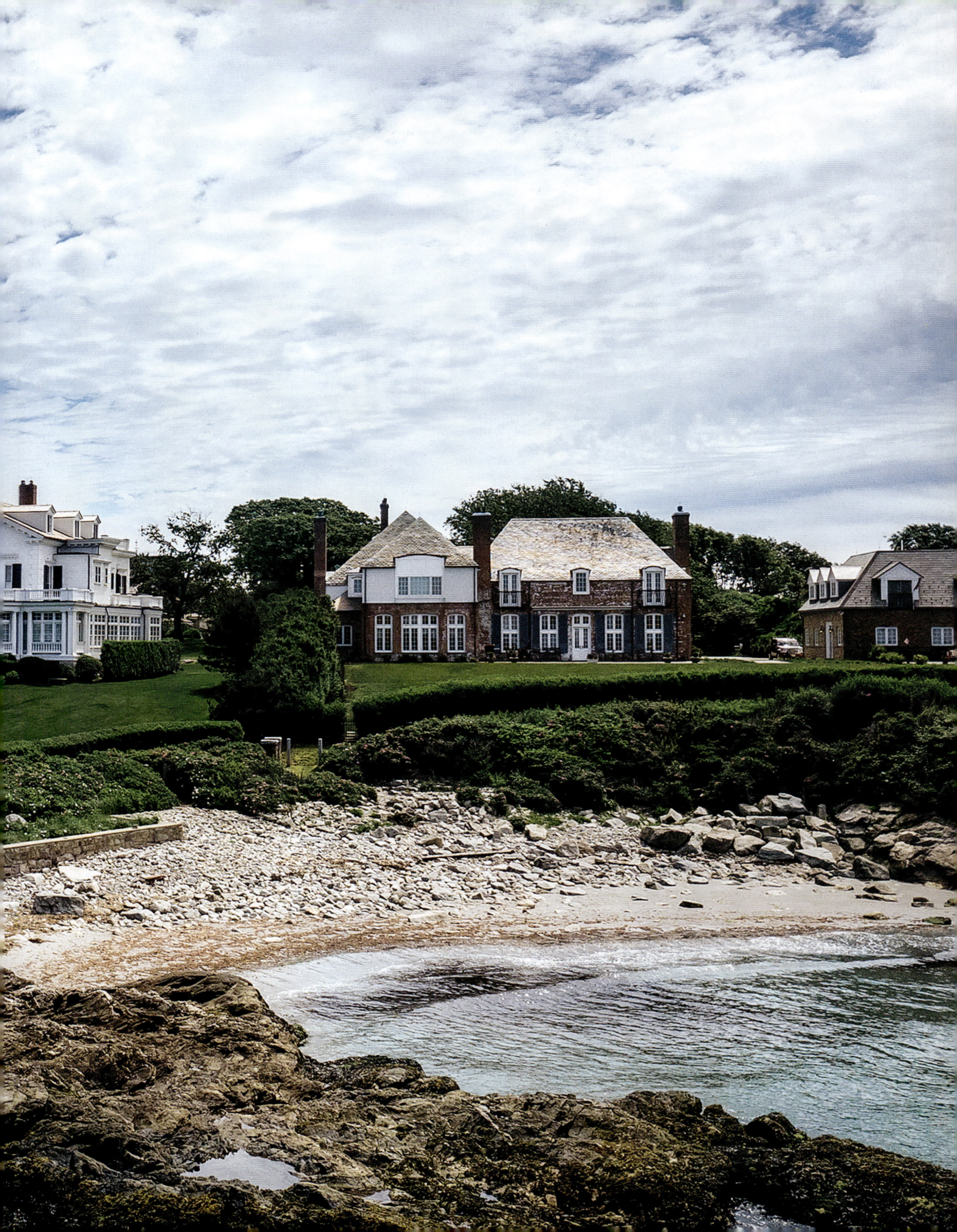

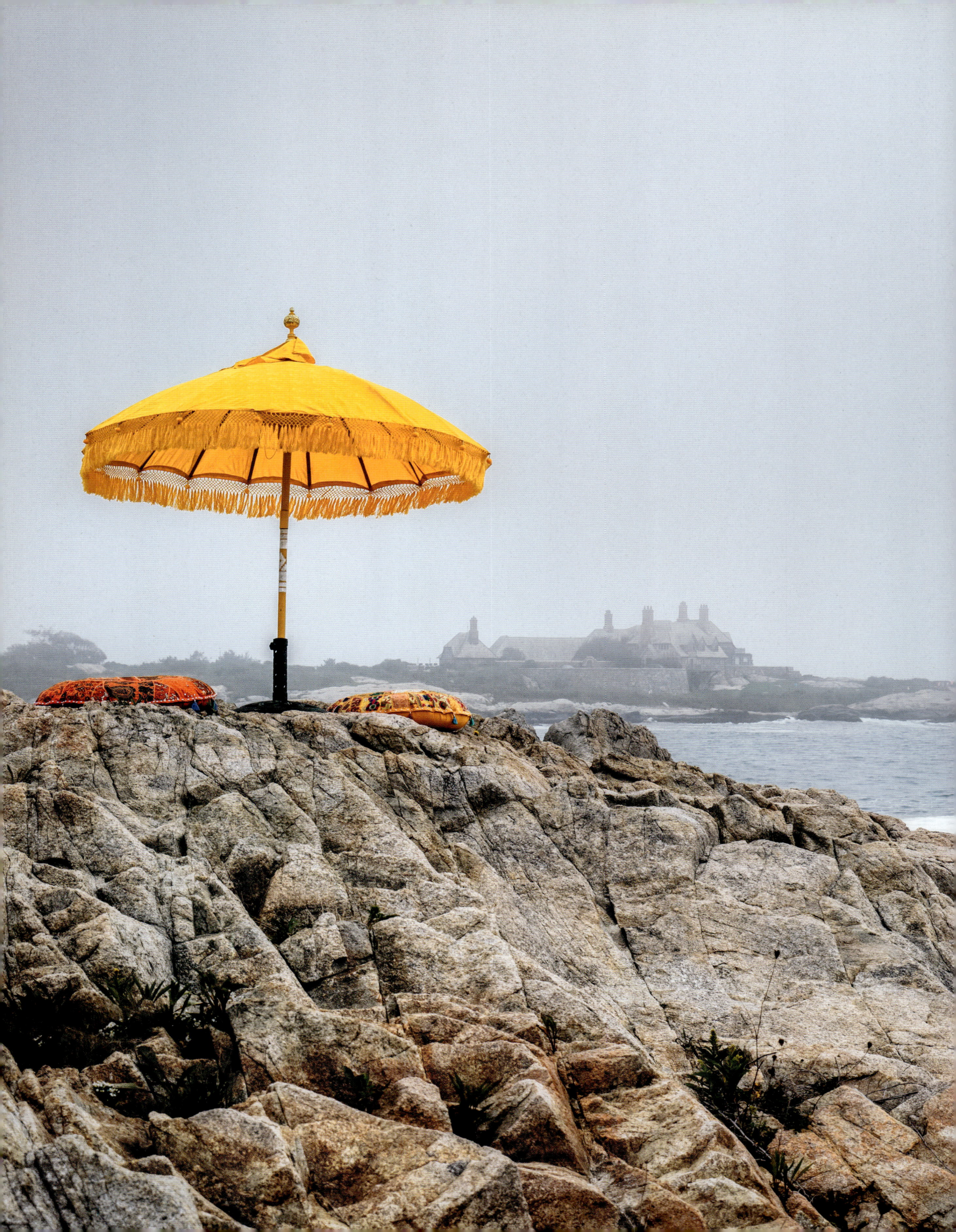

INTRODUCTION

Years ago, my future husband whisked me away to meet his parents at their summer home nestled in Newport's historic district. The setting sun cast an orange and soft pink glow on the Ionic columns supporting the portico of the stately New England dwelling. I expected an interior as picture perfect as the gorgeous, hydrangea-dotted grounds. To my surprise, I was greeted by the antithesis of chic décor: a shell-pink-applianced kitchen with dated faux-marble countertops, condensation gathering on the past-its-prime refrigerator, its surface peppered with timeworn family photos.

After seven parties in three days, I was in love—with my man and my surroundings: the sixty-year-old lemonade-yellow tile in a shingled cottage; the bathroom filled with handwritten labels on sticky tape; pots and pans haphazardly hanging from pasty white peg boards in the city's most storied and famous homes. Everything was steeped in character that defied trends and achieved something else—a timeless imperfection that truly captured my heart. It felt like home and nowhere else at the same time.

Many books have been published on Newport society and houses, yet, as one can imagine, our small community prefers to keep the voyeurs away. Our world is private. We don't allow cameras in clubs and snub our noses at guests Instagramming private moments. But here we are publishing a book that we believe reveals the beating heart of our summer home.

A catapulting photography career notwithstanding, Nick Mele's shutter is set on the slowest speed. Unlike me, he is a Newport native, and his aperture, opening and closing since he was a teen, has amassed more photos of the town and its inhabitants than any one book can ever hope to contain. Calmly and deliberately, he absorbs the contents of every room

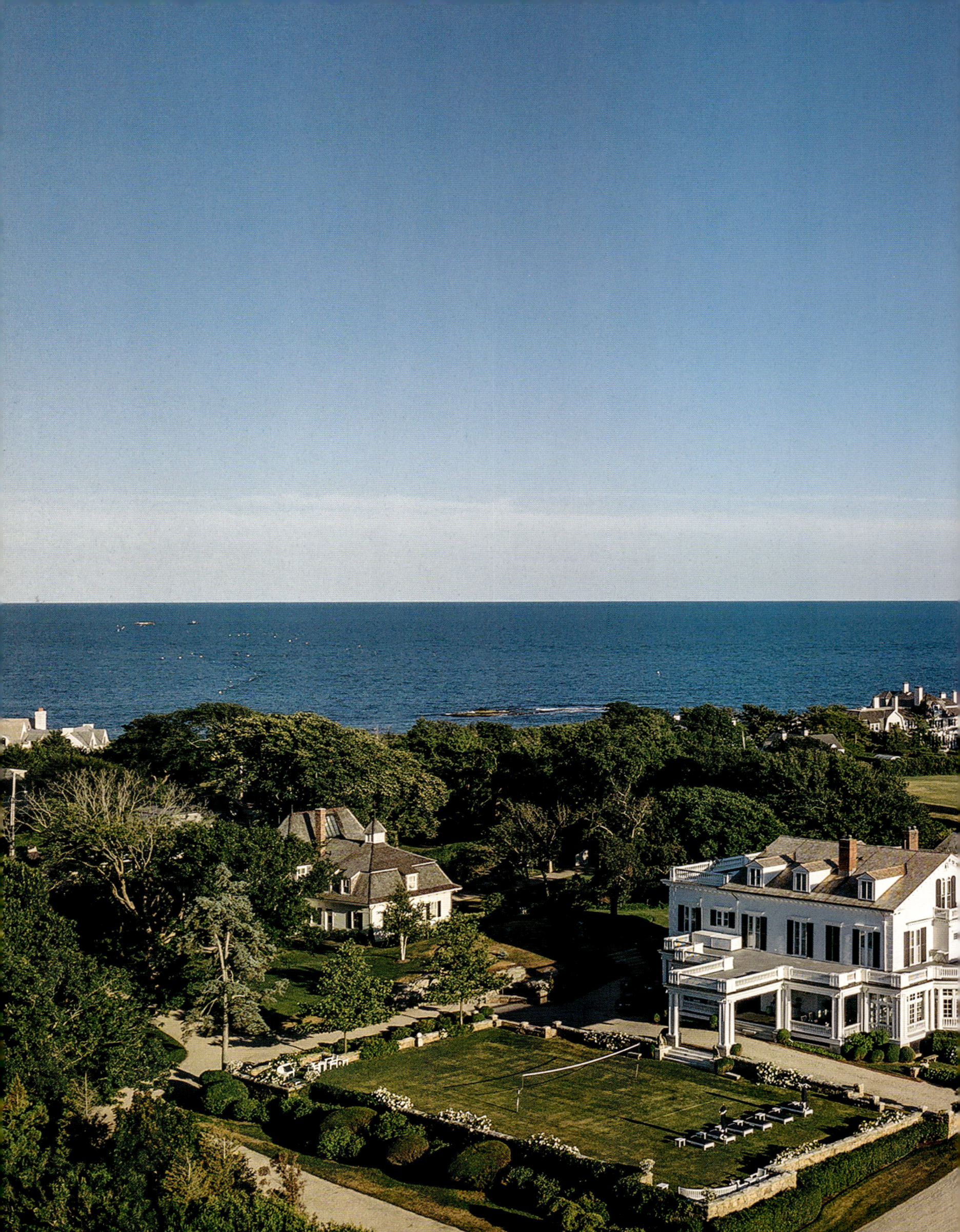

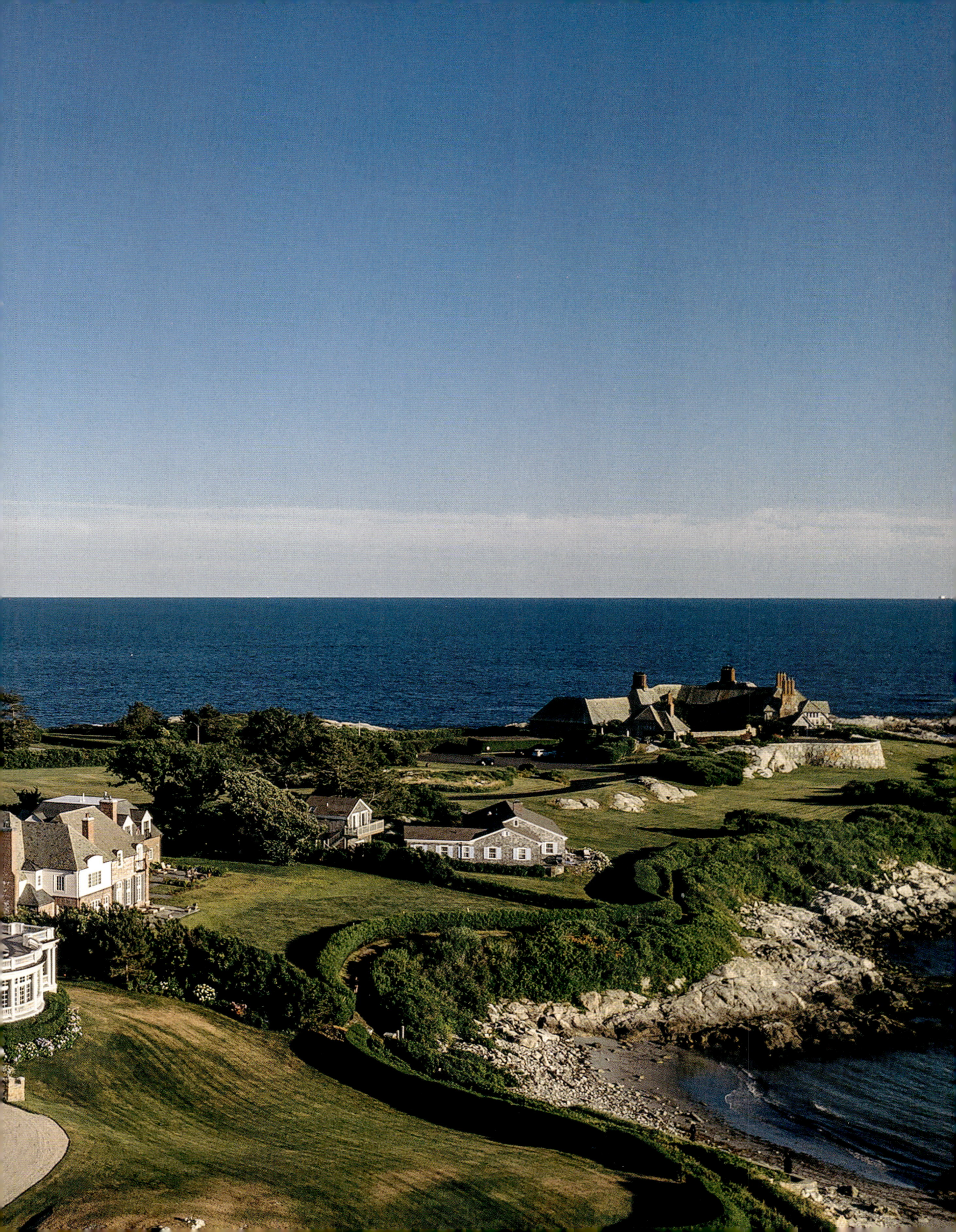

he enters and captures the essence of every person he encounters. In a world where novelty is revered, his images illustrate that the new, shiny object doesn't garner much attention in Newport. The latest newly renovated home, though appreciated and enjoyed, is not part of our acquired taste. Instead, we search for the new within ourselves. If "aging is truly a privilege denied to many," as Mark Twain believed, then we Newporters are fortunate indeed. Anti-aging does not exist here. The aged and the ageless go hand in hand. Our homes are unapologetic expressions of personality, a private geography where self-acceptance is a house rule amid all the peeling chinoiserie wallpaper and crumbling, cracking foundations.

To understand the true draw of Newport, one must experience this place through a filter of four. Four glorious months. Four pockets of time, each imbued with rules and rituals of its own. The "season," as we call it, is the reason to return, to entertain, to assemble in reverence of nature, family, and community.

June, July, August, September: These four months represent the heart, soul, and survival of our beloved seaside enclave. The anticipation and promise of June, the celebrations of July, the social whirl of August, the whispered good-byes of September. Faces tell our stories: the exhilarated expressions of couples dancing the night away in an annexed former art studio, the knowing looks of cousins exchanging confidences in a corner for hours. Our common denominator is our presence in the here and the now.

This book is our love letter to Newport for teaching us unspoken lessons we carry in our hearts. It flows into and around a connection to both the past and present. As a venerable member of our Newport summer colony likes to remind us, quoting E. M. Forster, "Only Connect!"

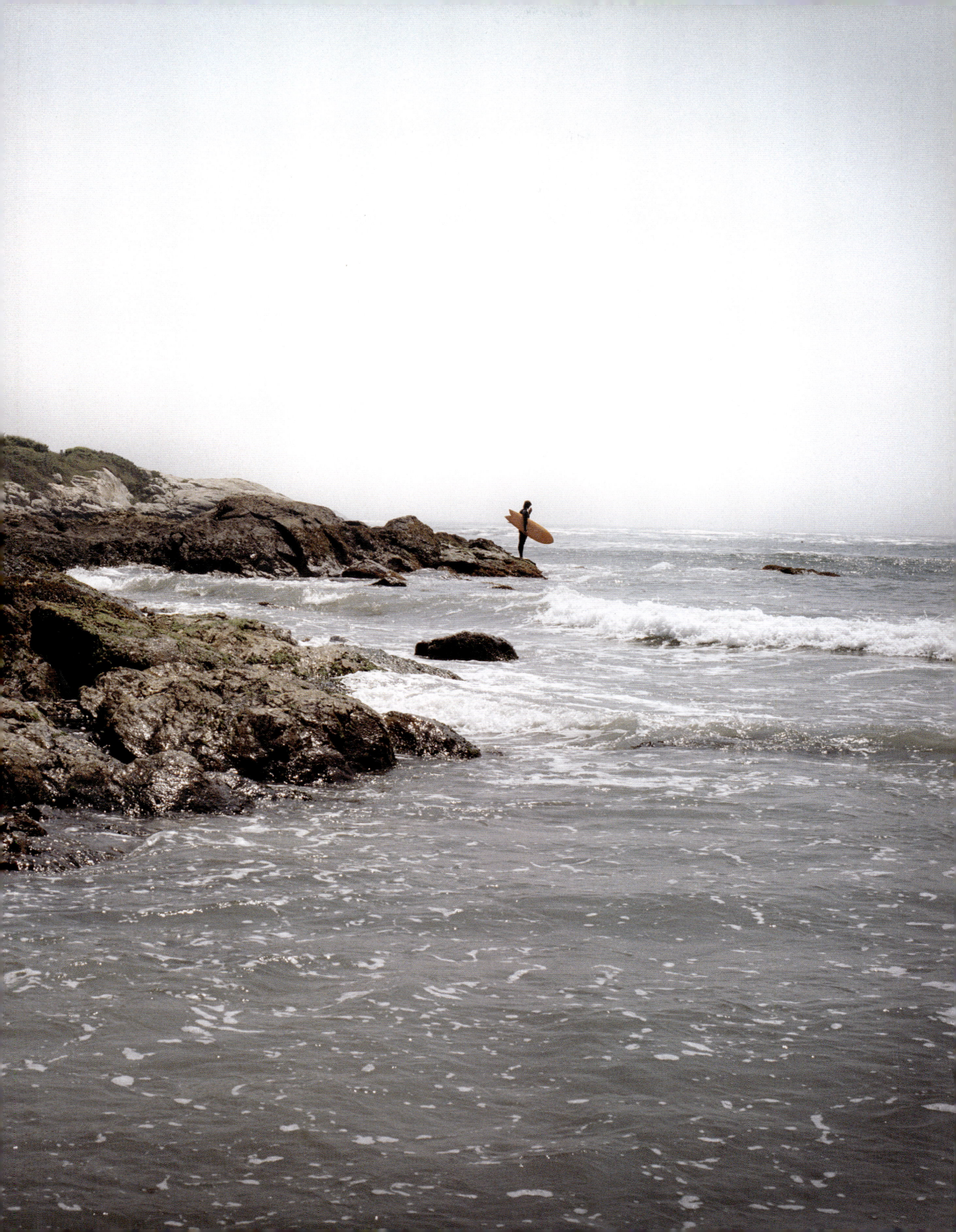

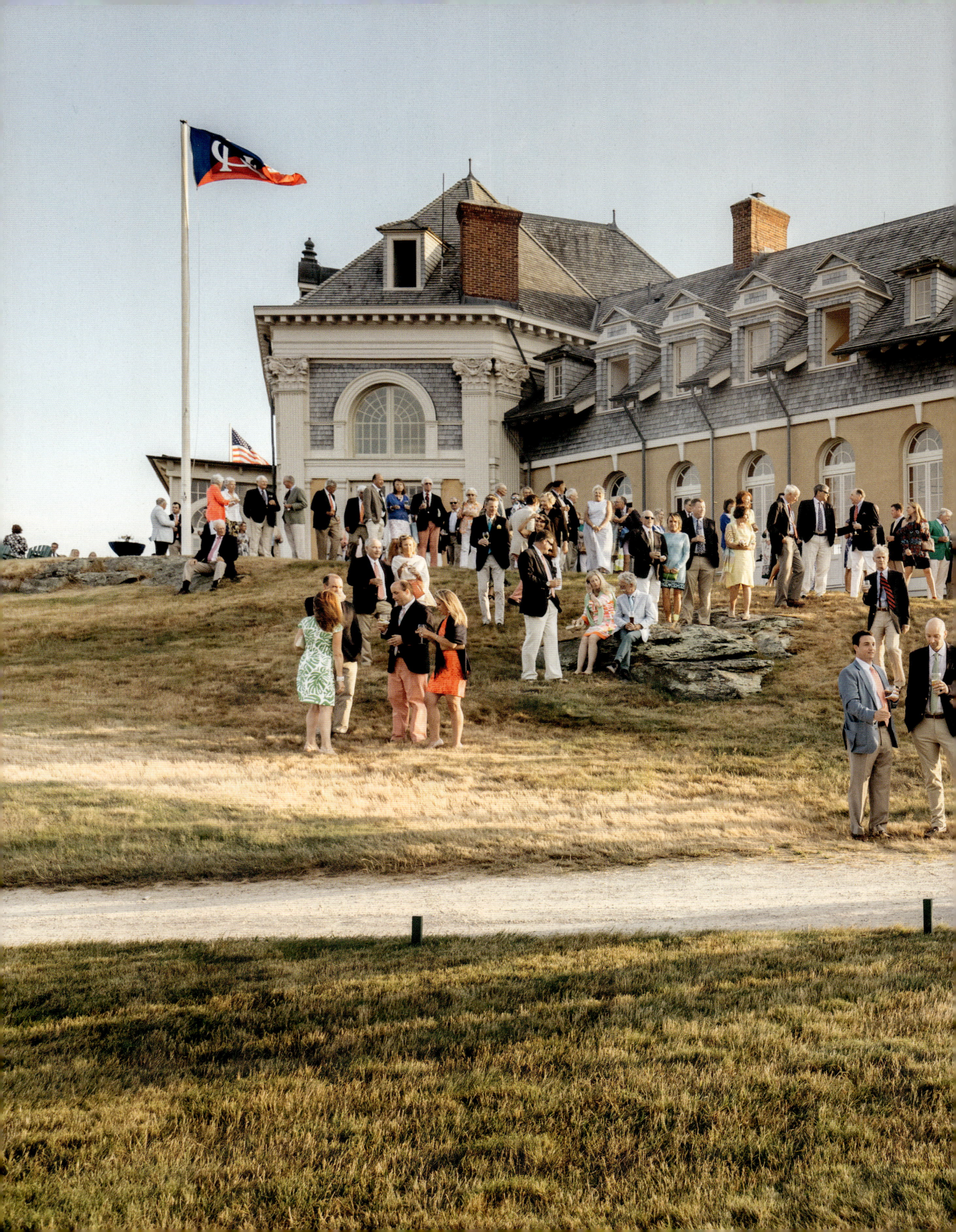

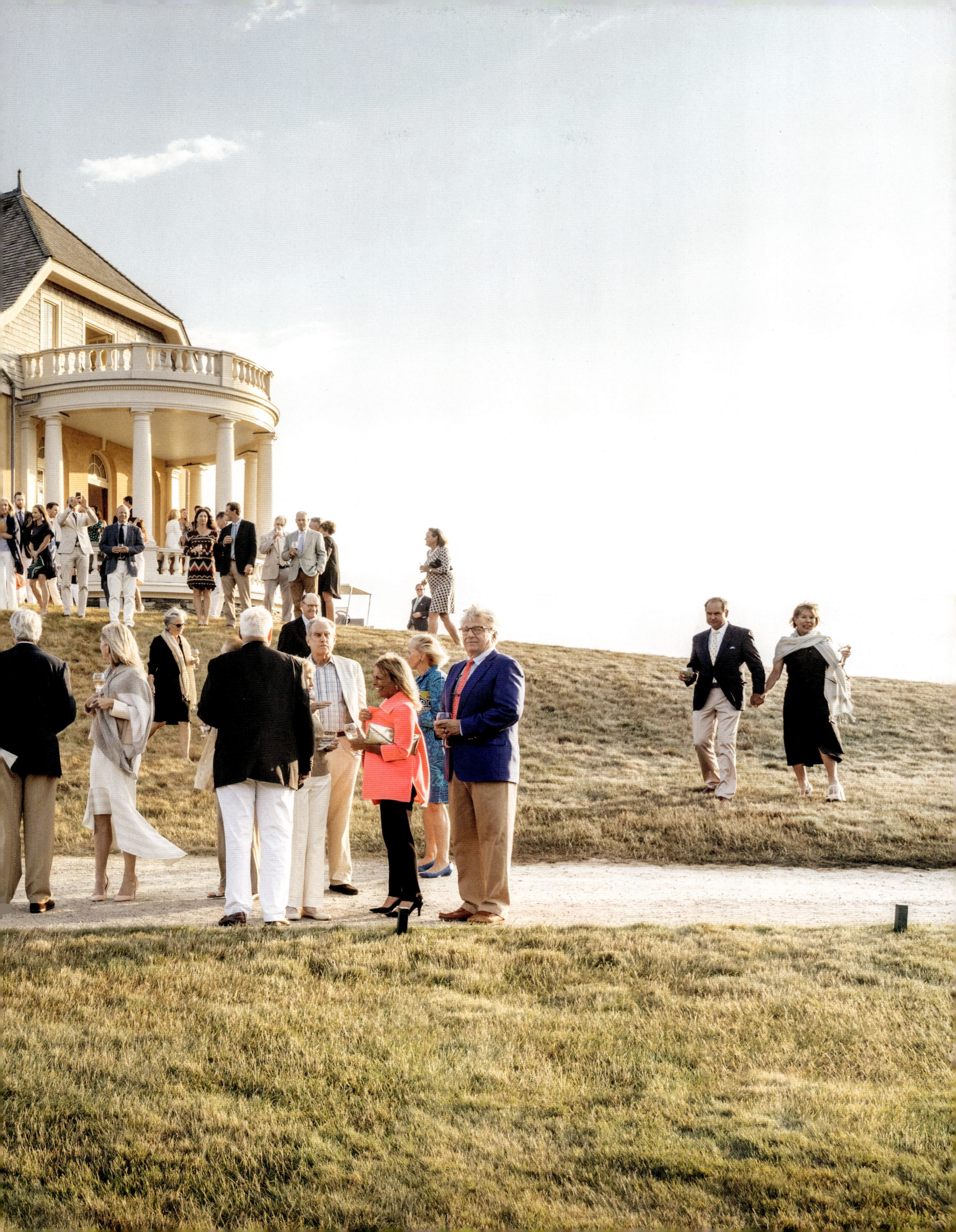

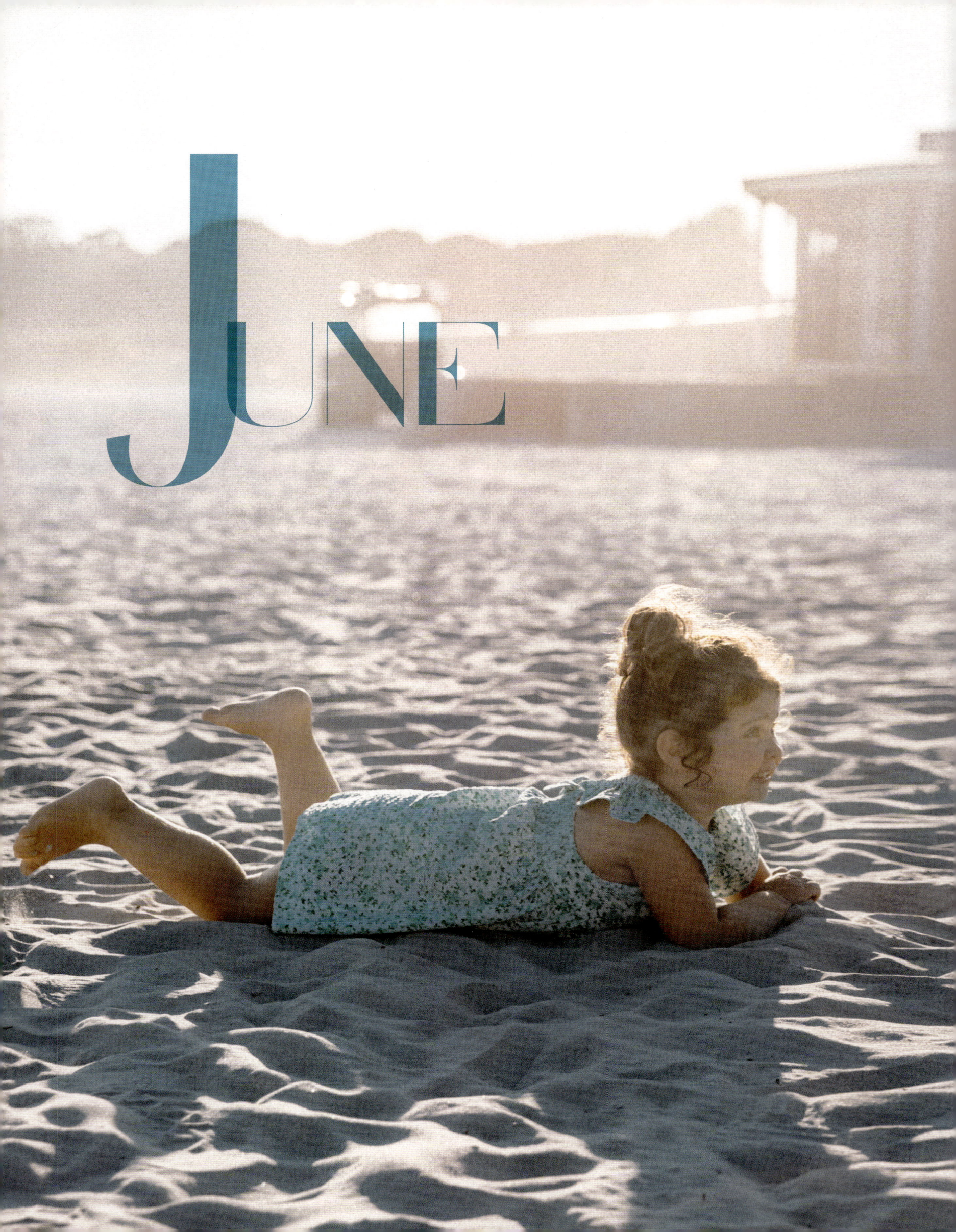

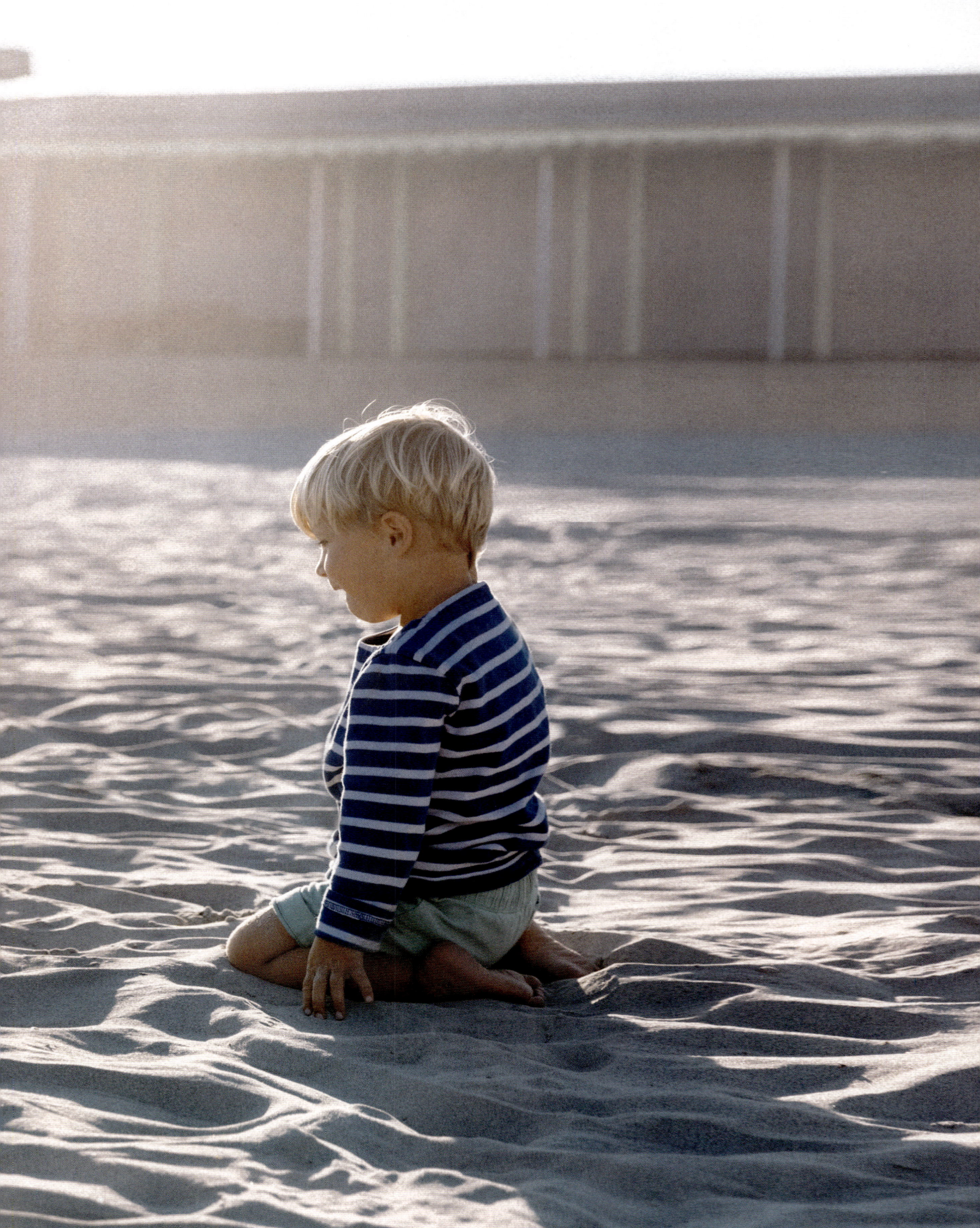

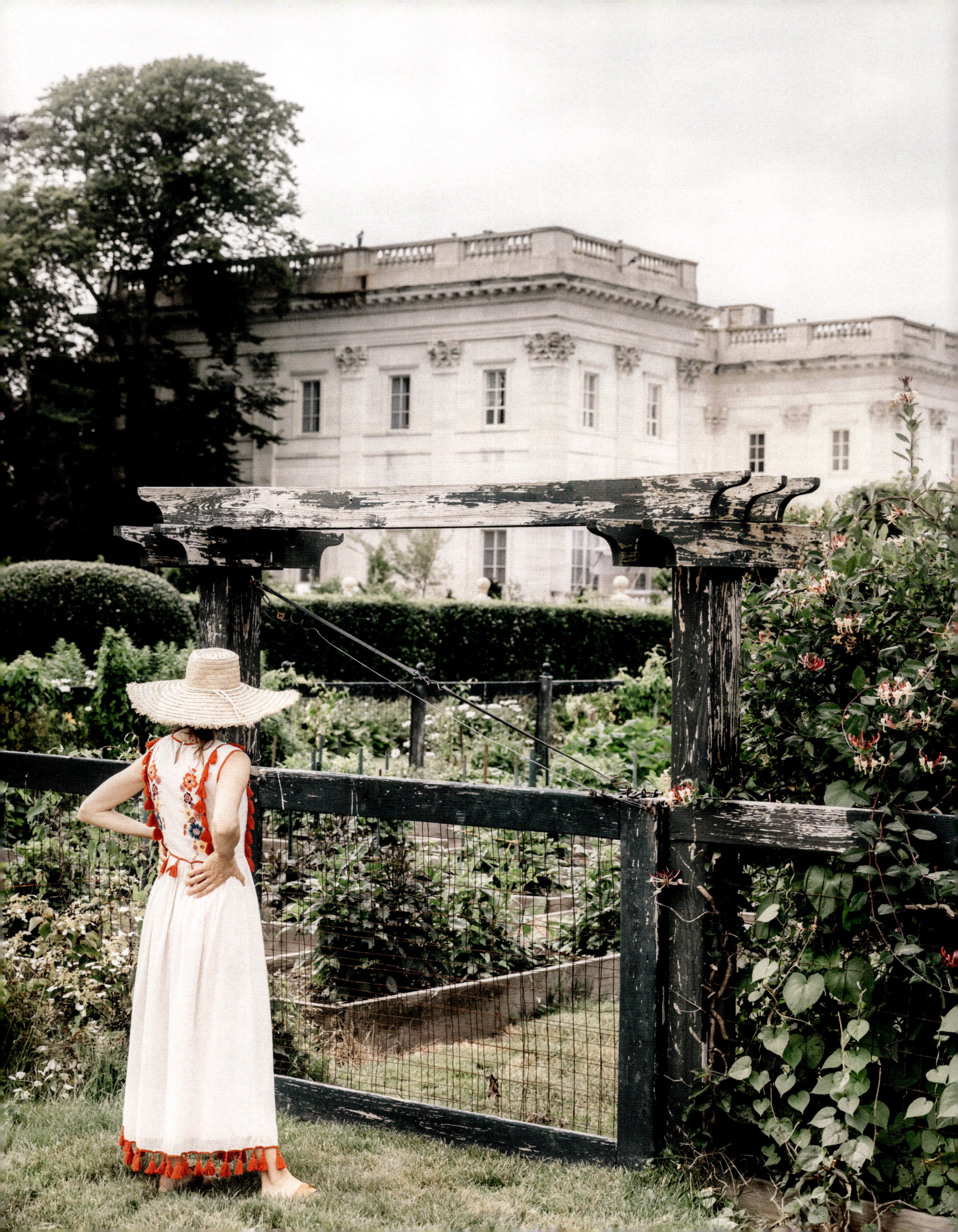

> *And so with the sunshine and the great bursts of leaves growing on the trees, just as things grow in fast movies, I had that familiar conviction that life was beginning over again with the summer.*
> —F. SCOTT FITZGERALD

I am six. My hair is in a side ponytail. My sister and I are wearing matching floral rompers with ruffled straps. They are sewn by Miss Stillwell and resemble her home's faint smell—Pine Sol and apple juice. Our aubergine station wagon's third-row seats are folded down, strewn with picnic blankets and pillows from our beds. From the backseat, I can see the side of my mother's face. She is smiling, a blue bandana wrapped around her hair, as she gazes into the rearview mirror, a silent exchange between us. My father has one hand on the map and the other loosely hanging out the window. We are in our chariot, windows open, barreling down a South Carolina highway toward our summer destination on a misty morning in June.

June was most likely named for Juno, the Roman goddess of marriage and women's well-being. Another interpretation is that it derives from the Latin *juvenis*, or "young person." To me, June is generous in her gifts for all generations. From the familiar scents of a beloved grandparent's home to the simple pleasures of reading a book by a pool, the inaugural summer month is full of promise. The new and the nostalgic will share her stage.

I imagine myself as Juno, strong and able, proudly carrying the baton of summer as I repeat history, awakening the children on the first day of summer. Sleepy yet aware, their anticipation is contagious. Our tribe boards a plane to Newport, Rhode Island, dogs and stuffed animals in tow. As we travel east, "Are we there yet?" will be answered by me countless times along the way.

The orange sun is setting as we cross two bridges and arrive in the coastal town. Tiny noses press against the windows as we inch down the main thoroughfare, admiring behemoth limestone mansions and historic summer cottages as if this were our first time on this road. Familiar thick green hedges nearly obscure the homes' hand-painted names. Seaweed, Champs Du Soleil, and The Ledges are among the signs that guard the secret stories of the past. My eldest daughter is the first to speak; peering over the seat, she kindly instructs the driver, "Follow the road, Sir. Our home is on the right, off Bellevue."

Beachmound is my husband's family's summer home, which our young children describe as a giant wedding cake. Gargantuan round hedges line the stone wall that separates the

house from Bellevue Avenue and the Atlantic Ocean. We occupy the cottage in the rear of the property, affectionately named "The Dumplet," as it was the main house's laundry facility more than a hundred years ago.

The first sighting of the faded-white clapboard structure reinvigorates our tired, hungry bodies. Infant lime-colored buds on the hydrangeas stand alert as we enter; their robust green stems and riot of periwinkle petals will soon fill every vase in our house.

The girls catch their second wind as they barge through the creaking cottage doors, squeals untamed in a dash to find their favorite belongings. I peek into the tiny closets to find pastel-colored dresses packed like sardines, just as I had left them the summer before, mysteriously looking just a pinch smaller.

New cracks in the ceiling are par for the course and will become old friends by August. I remove the sheets from the furniture and inspect the damp pantry contents, as if anything could survive a winter of solitude. Cursing the calcified storm windows is a rite of passage, I remind myself, as this is a small price to pay for the gift of this home from summer to summer.

Flopping on my bed, I revel in the joy of the clean sheets for a second, as sandy feet will be the uninvited guests all summer. Having lost the battle with closet space, colorful gowns hang on sconces. Hats purchased at the annual June flower show rest atop radiators and perch on the gilded frames of artwork. Yellowing tennis whites and slightly mildewed needlepoint pillows have long-time residency in our bedrooms, the only downside of moist ocean air. In authentic Newport fashion, it is not uncommon to see garments recycled year after year commingling with heirloom jewelry, neither of which will garner as much attention as the original soul wearing them.

Stacks of invitations await in my mother-in-law's black-and-white-checkered marble entrance hall. A costumed soirée for a grande dame, the Secret Garden Tour, and the Newport Yacht Club Annual Regatta are among the many heavy-weighted contents of the envelopes.

Juno has begun her yearly ritual, awakening homes, drawing the curtains open, welcoming residents who stream in from across the globe. Summer in Newport is about to commence.

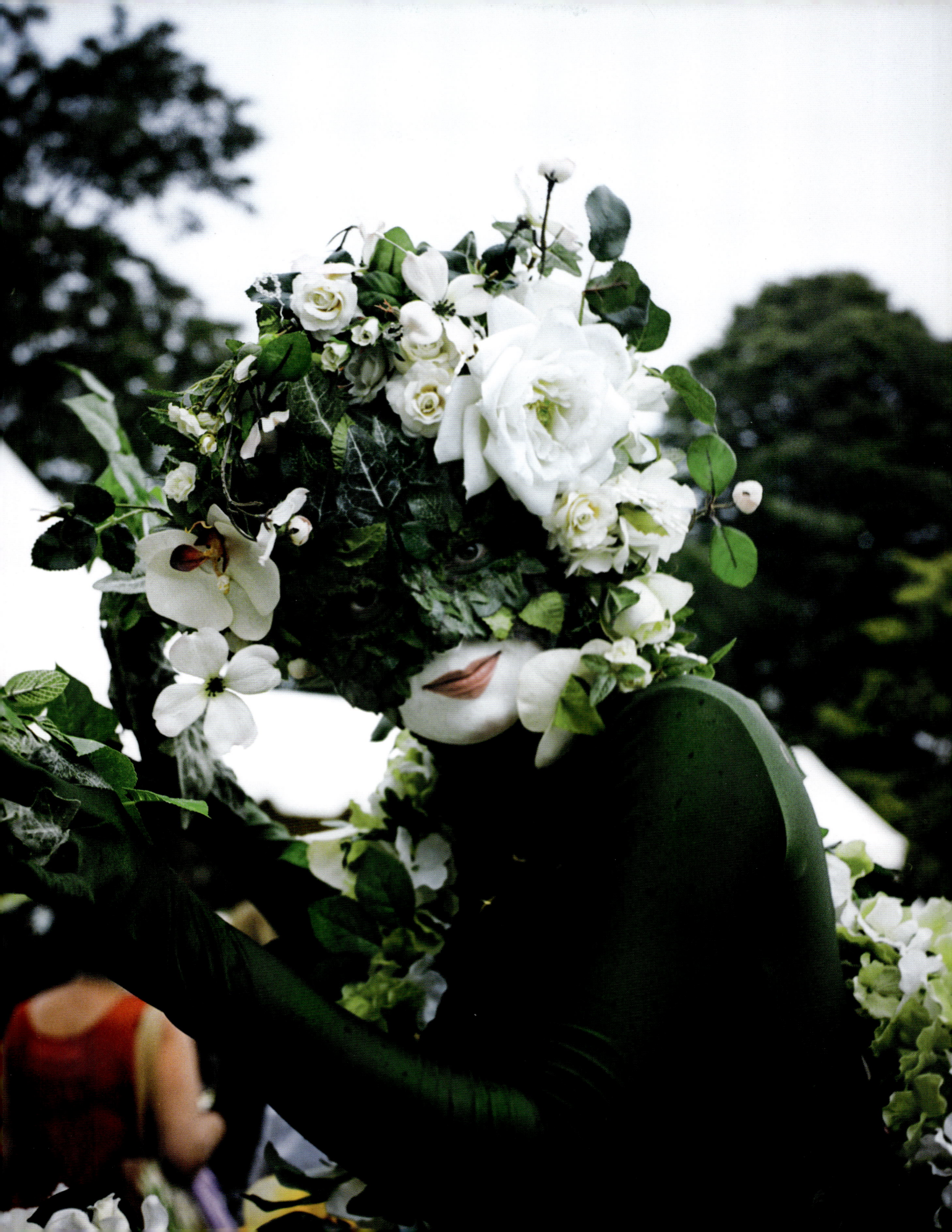

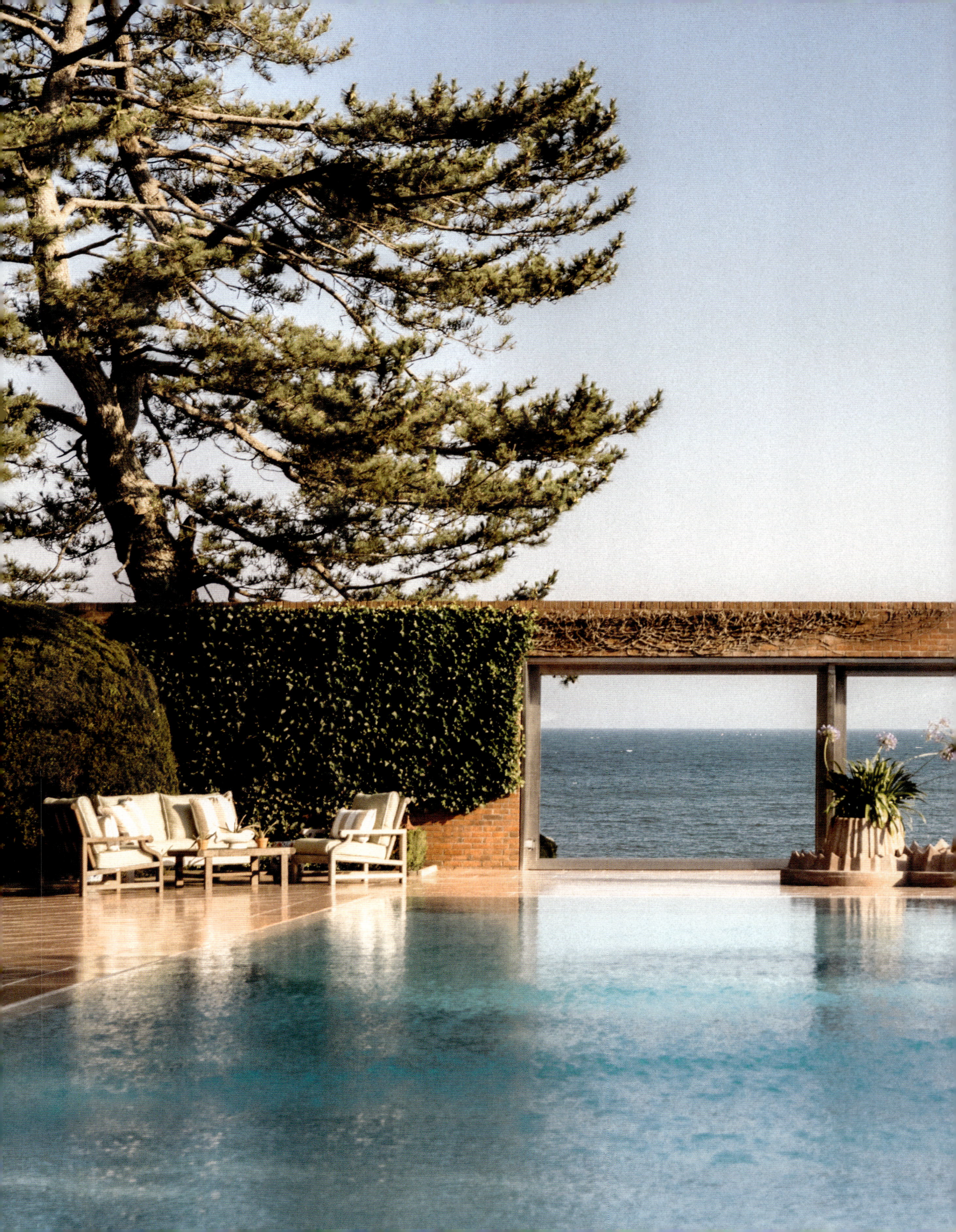

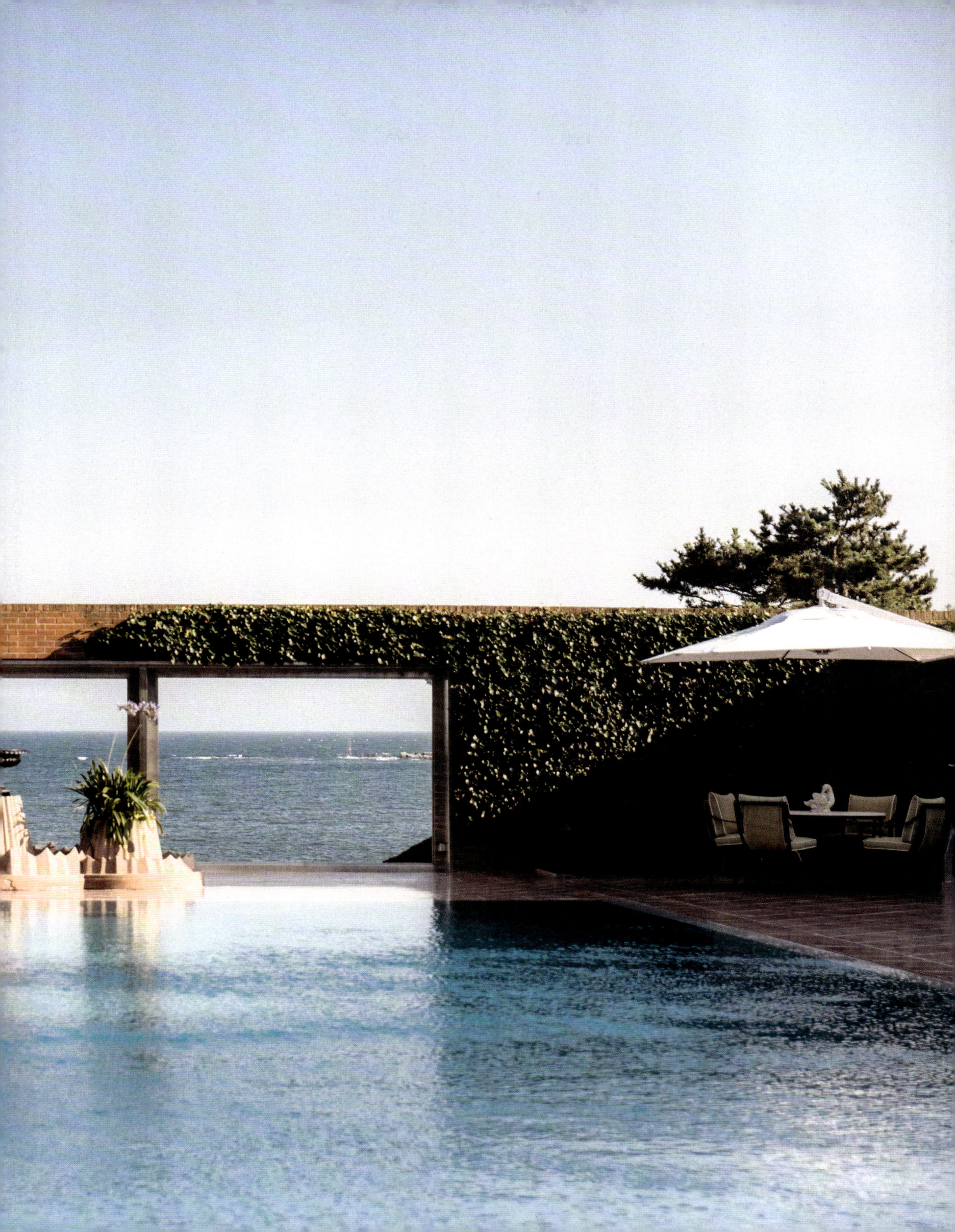

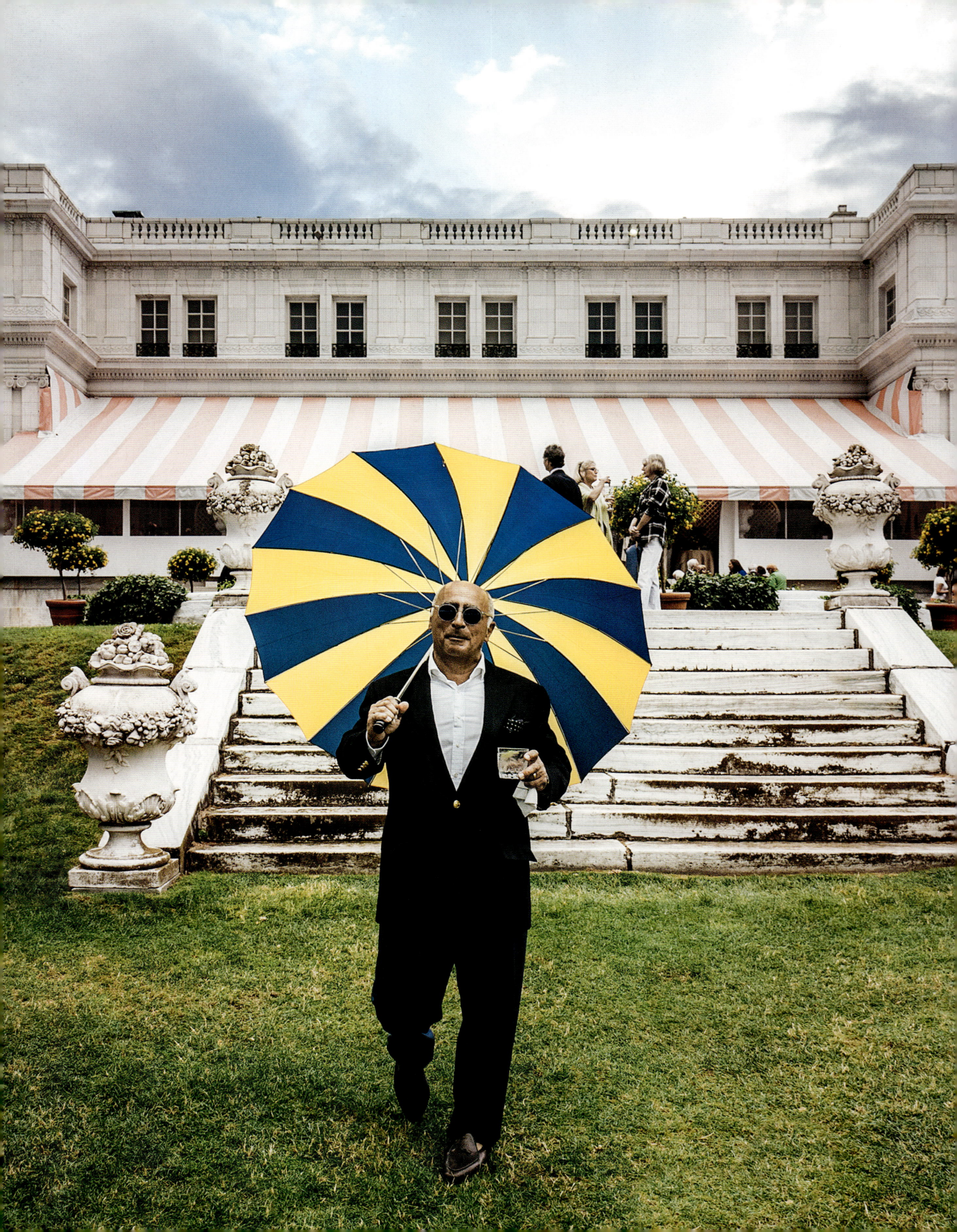

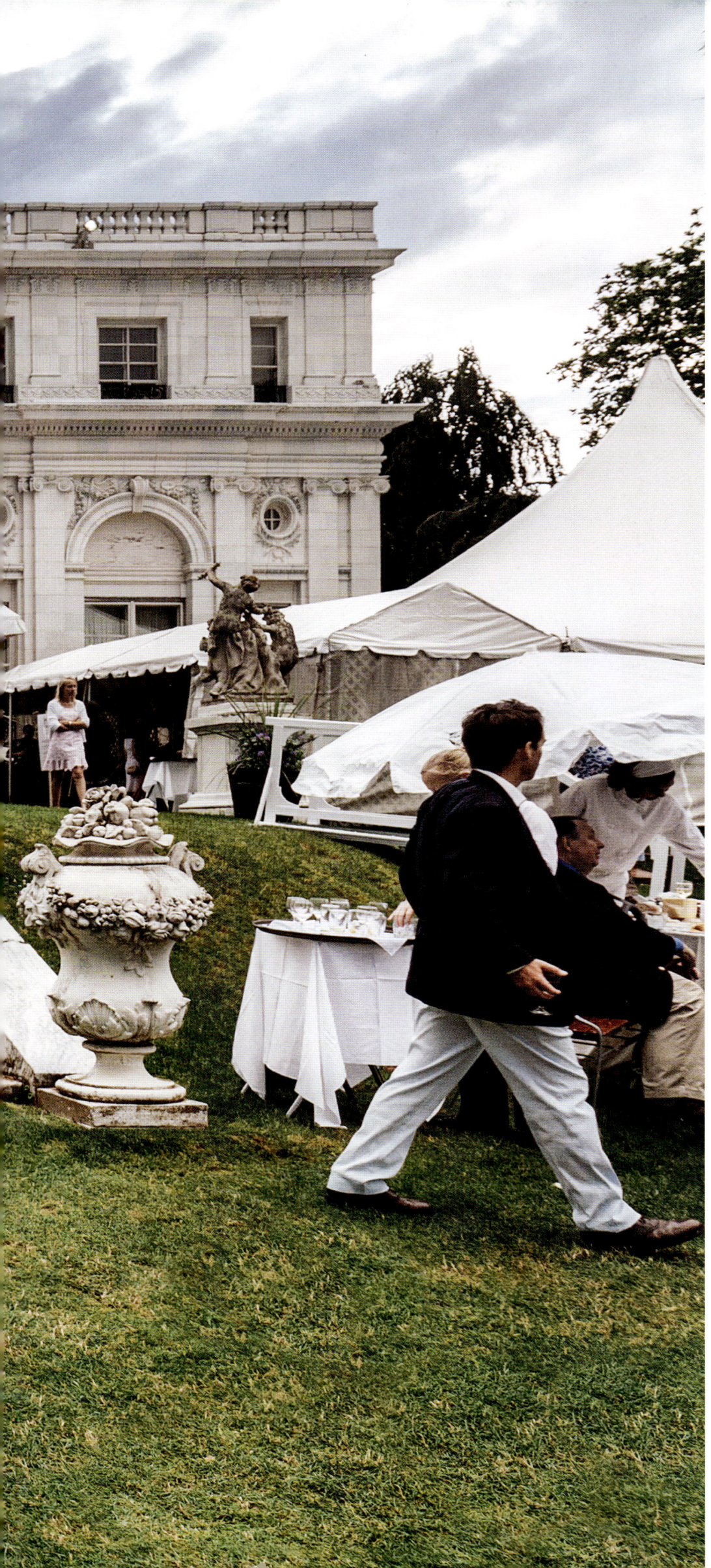

JUNE 31

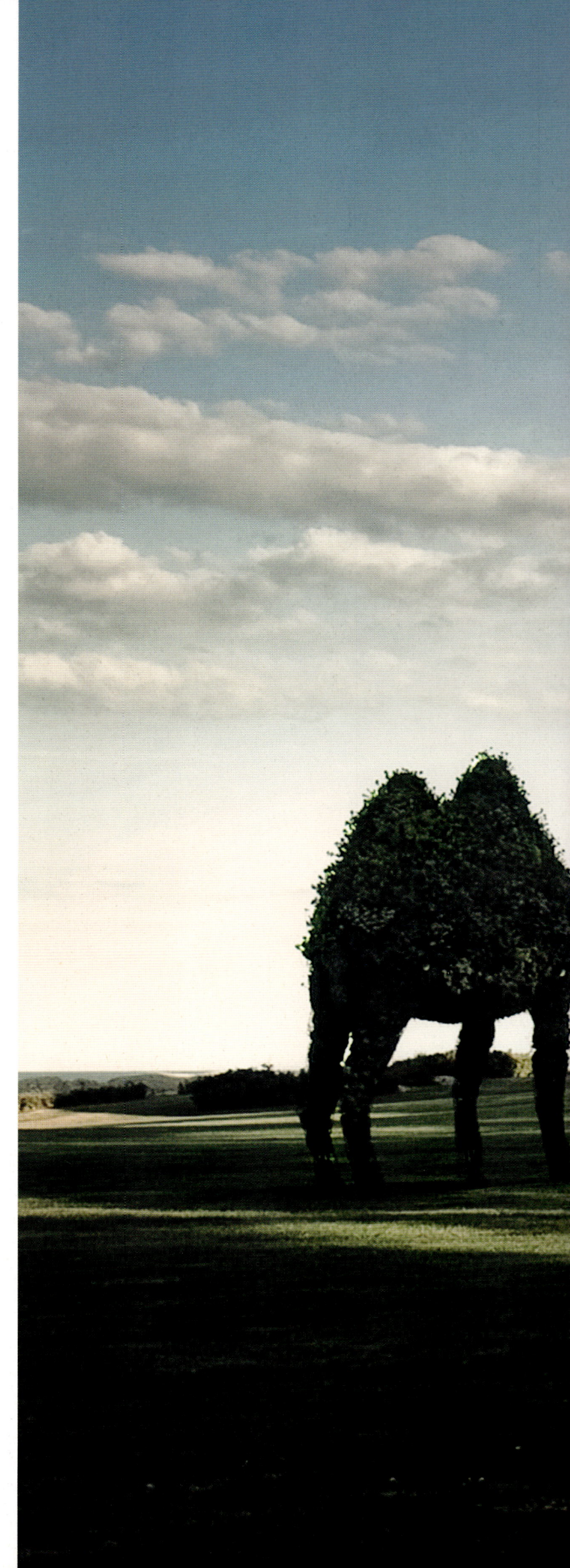

32 JUNE

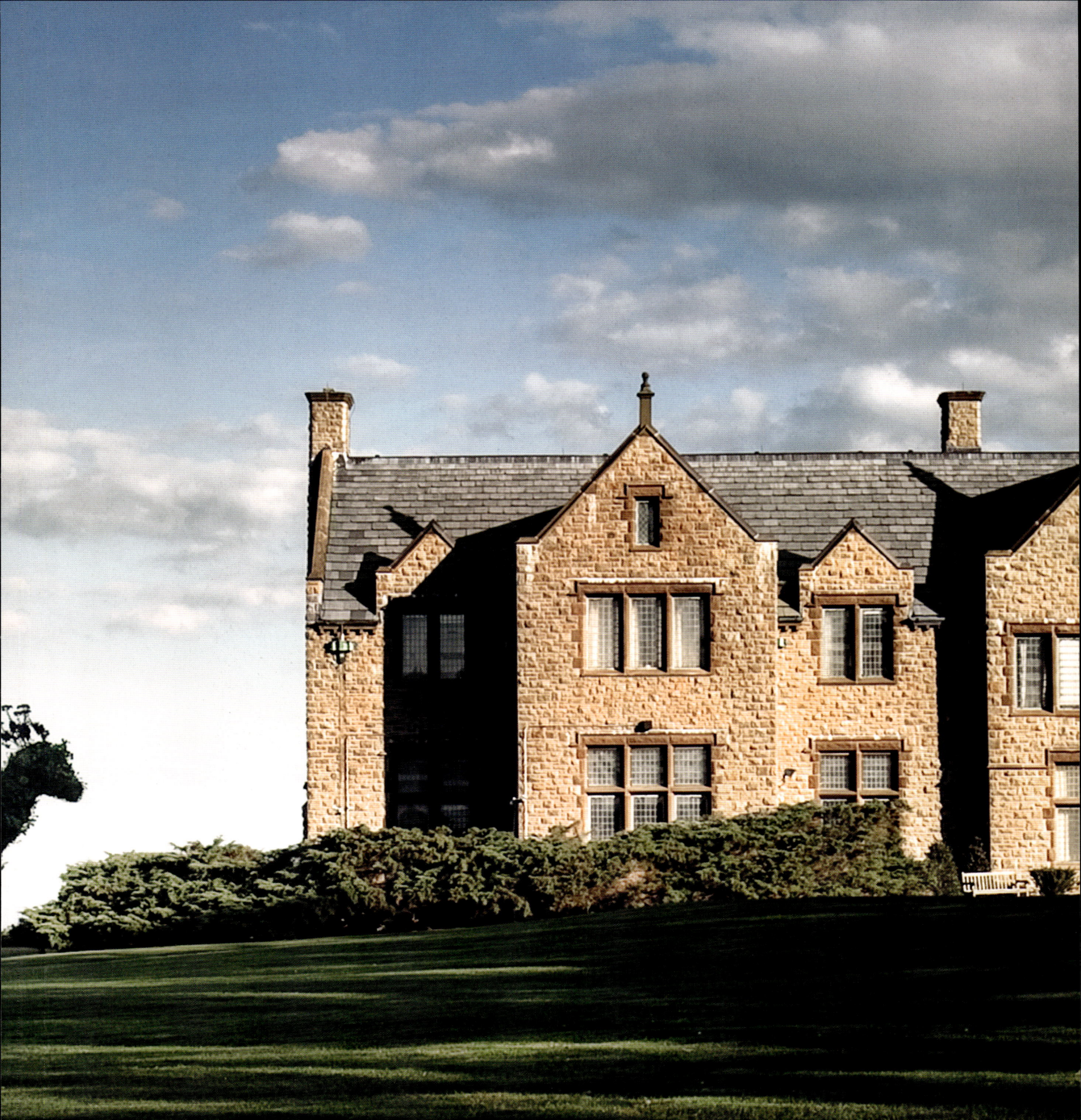

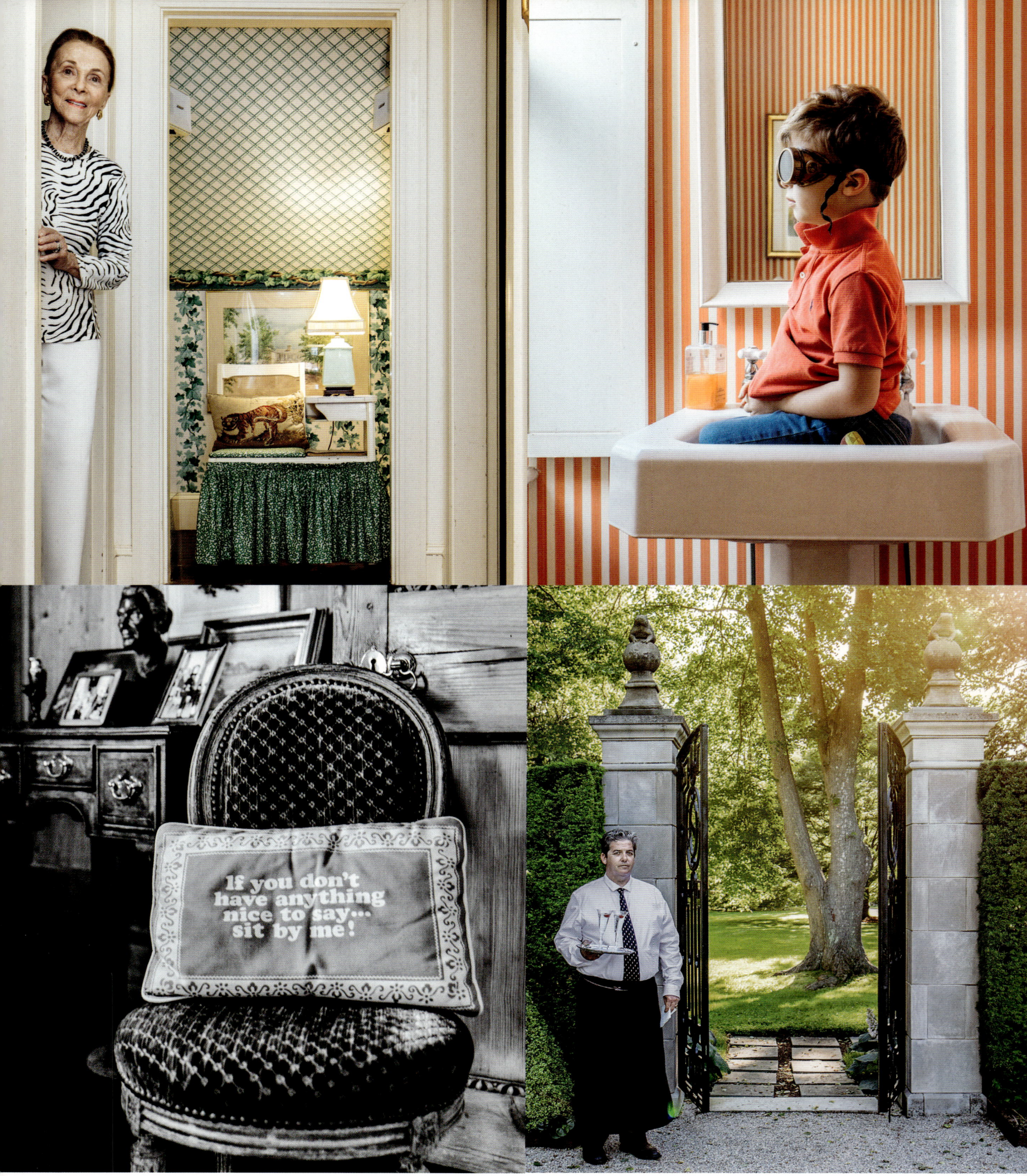

34 JUNE

JUNE 35

reduce to 6 3/4 inches between marks

NO VIEW

July

> *"Summer afternoon—summer afternoon; to me those have always been the two most beautiful words in the English language."*
>
> —HENRY JAMES

If June is the birth mother of summer, July is undoubtedly her wild child. Like our annual fireworks show, she explodes on the scene, dazzling and illuminating. As one event fades, another ignites. Whether flowing with the elegant grace of a 1920s waltz at the Breakers or shaking the dance floor under a bubble-gum-pink striped awning at the infamous Sky Bar, July pulsates in eclectic rhythms across the town. Generations of families drop anchor against the rocky coastline, preparing for the evening festivities. Houses stand erect, blousy hydrangeas bloom in vibrant gardens.

During the day, a calmer cadence reigns. A mother and daughter giggle after a tennis match played under the blistering sun on Ocean Drive. A friend putters down Bellevue Avenue in his family's shiny, aqua-blue, wood-paneled "grocery-getter" wagon wearing a Fleetwood Mac shirt, the same vintage as the car. Within the hour, the shirt will be replaced by a tuxedo. A backgammon board rests on an antique needlepoint table as cousins snicker and sneer, engaged in a decade-long rivalry. Teenagers sneak away to jump the cliffs at Spouting Rock, testing their bravery as their parents did before them. Toddlers, freshly bathed, sun-kissed, and sleepy, are swept off to bed to the chirping of crickets at dusk.

The French composer Claude Debussy said, "Music is the space between the notes." This quote reminds me of the connections and beauty that can be found in the silence. The space between notes allows us to resonate, reverberate, and reach our full measure of expression. I experienced this melodic silence at one of our Sunday night family buffets. Seated next to me were two elderly gentlemen, one finishing the remnants of a lobster, sitting upright with a stiff white napkin tucked into his shirt. The other, intently focused on not allowing his ice cream to drip onto his tie, felt my gaze and returned it with a smile that melted me into my chair. His quiet eyes shared our silent song. All evening, the notes played out in my mind, a melody acknowledging the fragility and beauty of Newport in July.

When I asked my youngest daughter what July in Newport meant to her, "Freedom" was her answer. Sound scripted? Sure, yet apropos on numerous levels, from waving American flags to Instagram-worthy picnic tables. For a nine-year-old, racing toward the safety of a canary-yellow bathhouse provides refuge from a churning ocean. Sneaking into "Grandy's" pink-applianced kitchen for a piece of Costco coffee cake is the coup of the morning. Our

surroundings consist of faded candy-colored, seahorse-patterned culottes worn year after year by a beloved aunt or the chinoiserie figures that smile at us from the peeling wallpaper in the powder room. The daily sight of my husband's godmother dressed in five shades of purple, from shoes to hats to jewelry, never ceases to warm my heart.

Our weathered veneer may appear somewhat shabby to the outsider. Yet its familiarity blankets us in memories and tradition. And though we cherish the ageless and the aged, we also embrace the new. Art studios now serve as homes, as do converted gatehouses, caretakers' cottages, and even various bits of the mansions themselves—haphazardly divided over time to accommodate growing families, and sometimes the scene of afterparties with velvet ropes and light shows.

In the intense sun and heat of July, the hydrangea petals pass their peak and begin to crinkle like crepe, fading to muted blushes of speckled gray and periwinkle—colors less interested in our attention but no less glorious to behold. As July's palette softens, we, too, are softened, becoming gentler and deepening our connection to nature and family. Undeterred by this inspiring show of impermanence, we begin again. Onward to August and summer's last hurrah.

88 JULY

JULY 89

AUGUST

> *"When the destination becomes gracious, the journey becomes an adventure of beauty."*
> —JOHN O'DONOHUE

Roll out the red carpet! August—bold, venerable, and maybe a little pompous—has arrived. It is no surprise that the Roman Senate named the month for Emperor Augustus after his triumphant defeat of Marc Antony and Cleopatra. Leos, theatrical and passionate, saunter through the month, and Newporters follow in step. In a sun-drenched burst, we come into our own, embracing the rites of summer's finale.

I savor every last drop of summer, in my wilting garden or along the sea. Every single day I make the ritualistic trek to the infamous Cliff Walk, witness the waves' stamina, and dip my toes in the tide pools. The sea is summer's playground; its unpredictability teaches us to lose our own sense of control.

Find us boating barefoot with friends, hiking in a worn pair of riding boots, or dancing the night away balanced precariously on a bejeweled heel. The last month of summer dares us to hang on. And we do, with everything we've got.

Newporters are born entertainers. It's in the blood as much as any sense of style or fashion. We're also natural revivalists, playing by different rules when it comes to making a grand entrance. Repeat gowns become as familiar as our most beloved guests. Always happy to come out to play, they linger for just the right amount of time, never overstaying their welcome. Like many of us, they get better with age. For it is not the frock that steals the show but the smile and the presence of the person wearing it. The bond we have with those who came before us is inextricable. We are pieces of each other, and the puzzle is complete when all shapes, sizes, and edges meet.

As summer enters its third act, the grounds of the former homes of robber barons and industrialists and business tycoons are up-lit, illuminating verdant lawns and meticulously manicured gardens that have been preserved through years of tireless dedication and a never-ending parade of fundraisers. White-capped party tents come to life as fragrances permeate tablescapes and trumpets blast jazz-tinged notes. A gentle summer wind welcomes guests, while place cards do their part to curate conversations. Their collective secrets, borne on breezes, sweep through the city just as they have for the past 350 years. No place understands and respects the magic that these outdoor spaces create quite like Newport.

More than anyplace else, the city respects the art of revival, the spirit of revelry, and, dare I say, a restraint not readily visible to the naked eye. If the interiors speak to our unapologetic, ragtag sense of style, the grounds of these summer "cottages" represent a more traditional splendor.

Newport boasts one of the most spectacular assemblages of American architecture you'll find. With a character both linked to the past and unburdened by it, the houses reflect a sense of self and individuality. From modest bungalows to sprawling estates, each home possesses its own distinct mood, attitude, and architectural bravado. Victorian-era detail mixes with Federalist and Colonial stature. Greek Revivals stand proud alongside sprawling cedar-shingled compounds.

We drive home in the fog from a party down Bellevue, tires bumping on the uneven pavement. The hustle and bustle of the day is behind us as gas lanterns, the first of their kind in America, flicker like fireflies. A quiet calm settles over the town. The end of summer is near. September is waiting in the wings.

AUGUST 151

154 AUGUST

AUGUST 155

SEPTEMBER

> *"And all at once, summer collapsed into fall."*
> —OSCAR WILDE

September arrives in a rush. School seems to call our children back sooner and sooner each year. Party fatigue sets in. It is summer's last gasp. The carousel horse is aching to break free, if only for a short while. Much like this carnival ride, Newport's season is cyclical and has its share of ups and downs, some jubilant, some mundane.

Despite all of this, I invariably hear the clichéd phrase every year, "This was the best summer ever." And it is usually true. If August filled my cup to the brim, then September is the month I get to savor it all. It is a measured, introspective time in Newport. No one party or particular evening or unexpected guest tips the summer scales too far.

For this very reason, I favor September most of all. It offers us the breathing room to reflect on the season's events. June, July, and August can be seen from a distance. Ida Lewis, Newport's revered nineteenth-century lighthouse keeper, understood the vantage point that September provides. She had a 360-view, an all-encompassing perspective that allowed her to persevere.

In September, we are nowhere else, just here, admiring a flag waving in the breeze against a moody sky, snipping off the very last hydrangea bloom for a vase, hearing a story from a new friend, sipping coffee before a morning swim. The end of summer blesses us with the little things.

Like September, Nick's photographs allow us to relive the summer's memorable moments at our leisure. They speak volumes about people, and because there is no need to "Hold still" in our digital age, his camera captures our world at its most candid and least posed. Images of dog and owner, libraries of dusty worn books, black-and-white photographs resting in solidarity on carved-oak mantels.

I take a walk to say good-bye to Newport before I pack up our little cottage. In June, on this same walk, I would prance down Ocean Avenue. But now I shuffle, crunching the leaves, mourning the green grass, and lingering, reluctant to leave this magical arena. The broken screen door handle that berated me all summer now gently closes for the last time. Are the local residents relieved as the throngs of summer revelers depart? Can the trees take a better sip of air without the hustle and bustle of the crowds? Perhaps September is the conduit, allowing the current of memories to flow while creating new pathways for the year to come. This was the best summer ever.

I Had a greate summer With You gie's I cant wait til you come to NYC and we mite come there next weekend But if we ciome to NYC I had fun with R will order a

Bailey
Love Kingsley :)

ACKNOWLEDGMENTS

First and foremost, this book is dedicated to my family. It is an ode to my grandmother Oatsie, from whom I learned the importance of good manners, good taste, good humor, and just a hint of naughtiness. It is a testament to my father, who's always dared me to be different and encouraged me to follow my passions. It is a nod to my mother, who's never cared who you were or where you came from as long as you were interesting. And it is a credit to my amazing wife and kids, whose support has been unwavering. Thank you for being my constant muses, despite your reluctance to stand still. You are my world.

This book is my love letter to Newport. It is the culmination of twenty years of taking photos and is as much about the people who aren't in it as it is the ones who are. Sadly, I couldn't fit everyone I wanted into these pages (my editors have said to blame them). The extended families and individuals who make up the summer community in Newport are what make it so special. Thank you to the Bakers, Bardeses, Bohans, Braffs, Buntings, Burnhams, Caseys, Cavanaughs, Cheathams, Colemans, Cowleys, Cullens, Cushings, Damgards, Danas, de Neufvilles, de Ramels, Donnells, Gordons, Graces, Grosvenors, Gubelmanns, Hamiltons, Harrises, Hudsons, Hulls, Ishams, Joneses, Kiellands, Kiernans, Laphams, Leathermans, Manices, Mathesons, McDonoughs, McLennans, Newhouses, Ohrstroms, Olympitises, Orthweins, Peixinhos, Pells, Princes, Quinns, Rosses, Slocums, Spencers, Tolands, Trainas, van Beurens, Van Pelts, von Auerspergs, Warburtons, Warrens, and Wood Princes. A special thank you to Bettie Pardee and Sam Bolton for seeing my potential early on and helping me produce a lot of the shots that are in this book. I would also be remiss if I didn't thank the Douglases for welcoming me to the family and putting up with me ever since.

I've been told that Vendome doesn't usually publish books with people in them. So, I thank them for taking this chance. I thank Mark Magowan for seeing something in my work and for his guidance in what is the first major collection of my photos. I thank Jackie Decter for her keen editor's eye, and I thank Rita Sowins for putting my photos together in ways I never imagined. They created a narrative where formerly there were just snapshots. Lastly, and most importantly, I thank Ruthie Sommers. I have long been in awe of Ruthie's talent and eye as an interior designer. She helped me to see the parts of Newport I may have otherwise missed. She got me to see beauty in the details. Even though it is my photography, her spirit can be felt throughout.

Nick Mele

I want to thank my mother-in-law, Pandy. Without her, I would not have my husband, my children, my home, and what has become my summer landscape—the incredible view of the Atlantic and the magical green lawn of Beachmound. I have immense respect for her values and generosity, her efficiency and thoughtfulness. I love our giggles on her bed, our outings to replace dinner with hors d'oeuvres, our French exits, her advice on my evening attire (especially when we first met), our endless tennis matches as partners, and her encouragement of my work, even if she was initially skeptical about this project. This is for you, Pandy!

I would like to thank my husband, Luke, and our daughters, Eloise, Bailey, and Posey, for allowing me to create a lifetime of costumes, gardens, entertaining, bad mom dancing, and obsessive dog adopting.

Thank you, Nick. I am honored to ride on the coattails of your extraordinary body of work. All the skateboarding, biking, driving, and secret styling of houses have been a tremendous joy.

My thanks to Stephen Drucker for suggesting the idea for this book to the one and only Mark Magowan. And to Vendome Press for immediately recognizing the insane talent of Mr. Mele. Thank you to Rita Sowins for channeling our vision in her impeccable design and to Mark and Jackie Decter for keeping Nick and me in step, trusting us with our love letter. And Jackie, when you approved my text, you made me the happiest writer in the world.

One last thing. Our idea for the book commingled with intergenerational friendship, which is what the book is truly meant to convey. Meredith, my best friend in Newport, who resides in the house her husband's grandmother lived in, and I are both Newporters by marriage. Our husbands have a pack of inseparable friends who grow closer by the year, regardless of location, and meet in Newport every summer. Three generations of friendships wound together, creating a fascinating, interconnected lattice that serves as my foundation in our small seaside community. Many years ago, I had the pleasure of designing Meredith's house with her husband, Patrick. Now her youngest and my eldest are best friends. My father and mother-in-law danced until the wee hours on the same floors I now dance on. I can imagine their heels burying into the gravel driveway at the afterparty every time I remove my own shoes in the entranceway. And as I look at our children playing on Meredith's lawn, I know we created more than a home. We created the next generation of friendships, and I hope this story lives on and on and on.

And finally, thank you to the trees and the ocean and the sunsets. Because of you, my heart is full.

Ruthie Sommers

A Newport Summer
First published in 2022 by The Vendome Press
Vendome is a registered trademark of The Vendome Press, LLC

VENDOME PRESS US
PO Box 566
Palm Beach, FL 33480

VENDOME PRESS UK
Worlds End Studios
132–134 Lots Road
London SW10 0RJ

www.vendomepress.com

Copyright © 2022 The Vendome Press
Text copyright © 2022 Ruthie Sommers
Photographs copyright © 2022 Nick Mele

All rights reserved. No part of the contents of this book may be reproduced in whole or in part without prior written permission from the publisher.

Distributed in North America by Abrams Books
Distributed in the United Kingdom, and the rest of the world, by Thames & Hudson

ISBN 978-0-86565-396-2

Publishers: Beatrice Vincenzini, Mark Magowan, and Francesco Venturi
Editor: Jacqueline Decter
Production Director: Jim Spivey
Designer: Rita Sowins / Sowins Design

Library of Congress Cataloging-in-Publication Data
available upon request

Printed and bound in China by 1010 Printing International Ltd.

First printing